Machine Embroidery

INSPIRATIONS FROM
AUSTRALIAN ARTISTS

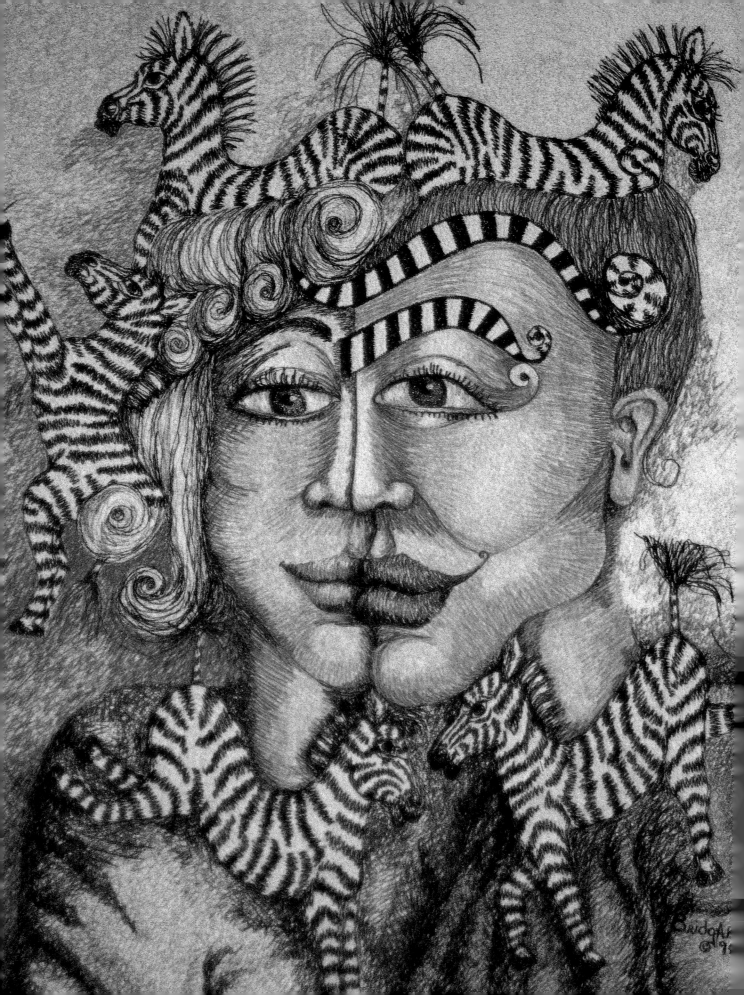

Machine Embroidery

INSPIRATIONS FROM AUSTRALIAN ARTISTS

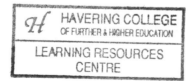

CONTENTS

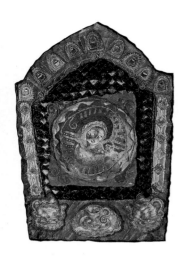

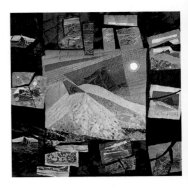

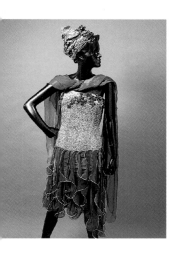

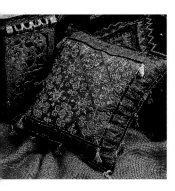

INTRODUCTION

I'm a dedicated fabraholic. Playing with bits of material and my sewing machine is the best way I've found to express myself — and I'm not alone. Like minds tend to attract one another and, over the last twelve years that I have been working with machine embroidery, I've met and formed lasting friendships with many other textile artists, including several who share my love for machine embroidery. All of the artists in this book are friends and colleagues whom I've met while teaching, exhibiting or writing. I am proud to be an Australian textile artist and I am delighted to join with my friends in sharing with you some of our passion for machine sewing.

Australia is a long way from the rest of the world and I think that Australian artists have developed their own unique styles partly as a result of this isolation. By experimenting, and playing with our sewing machines we've discovered new and exciting things to do with this previously utilitarian appliance. Often a formal training in art has contributed to an individual's desire to create with colour and line, shape and texture, but the overriding passion with all of us is the sensual and seductive feel of fabric.

Annemieke Mein attributes this passion to our earliest memories, of being comforted with the touch of fabric against the skin. As we grew older, the flexibility of fabric seemed to be the most expressive surface to carry our visual message, whether decorative, conceptual or functional.

Although many Australian textile artists have early memories of working with hand embroidery, the sewing machine has been welcomed by all of us as a technological innovation that contributed one essential element above all — speed. Textures and patterns can be achieved in a fraction of the time taken for handwork, allowing our creations to fly freer and higher, wider, faster and grander than could be achieved any other way. Drawing with the machine on fabric is almost as fast as with a pencil on paper. At last, a technique that can keep up with our soaring imaginations!

For some, the stitch is everything — sewing lines with threads on fabric to create an image as rich and subtle as a pencil portrait. For others, the machine becomes the tool that draws together many different techniques, like dyeing and manipulating fabric, or joining such diverse elements as plastic, paper, foil and fabric. Unusual techniques such as photo transfer printing combined with machine embroidery create haunting images, where reality blends with artistry.

Fabrics can even be created by the machine itself, stitching threads and yarns together over the magic of water-soluble fabrics or empty space to create laces which look as fragile as a cobweb, but with the strength and speed that only a sewing machine can provide.

New technological developments are happening all the time, and the computer is now part of many sewing machines, where images can be planned on a screen, and sewn later by the machine, allowing the artist even more freedom of expression. However, having a bigger box of coloured pencils doesn't automatically guarantee an ability to draw like Michelangelo. A true artist can create magic with a stick in the sand or a finger on a foggy window. It's the soul and the individual talent of the creator that makes the difference.

In this book, you will meet eleven Australian artists, all of whom love their sewing machines and are passionate in their commitment to their work. Each artist shares with you their journey towards the successes they enjoy today — a journey requiring dedication, imagination and years of hard work, combined with a little luck and a lot of good management. Many have confided that they find their work addictive — an activity they see as 'soul-food', an urge they can't deny. All of them are experienced teachers who love to share their skills with students all around the country — from tertiary colleges in major cities to tiny outback communities where the welcome is as warm as the surrounding desert.

This is a book about ideas and inspirations, not specific projects. Each artist takes you step-by-step through some of their favourite techniques, which are demonstrated in the beautiful pieces they have made specifically for this book. We encourage you to try these techniques, then apply them to your own work, in your own way. Feel free to change, develop and combine techniques, and to build on them to create something that is uniquely your own.

The actual techniques are not difficult to achieve with some practice. Follow the advice of the artists in the book — practise, make samples, learn from your mistakes, have fun and play, play, play. Then you'll be ready to fly solo, and experience for yourself the joy of creation.

I would like to dedicate this book, with love and appreciation, to the people who made it possible: my husband, Richard; my friends and colleagues; the artists in this book, and to Bernina, especially Michael Orvis.

Kristen Dibbs

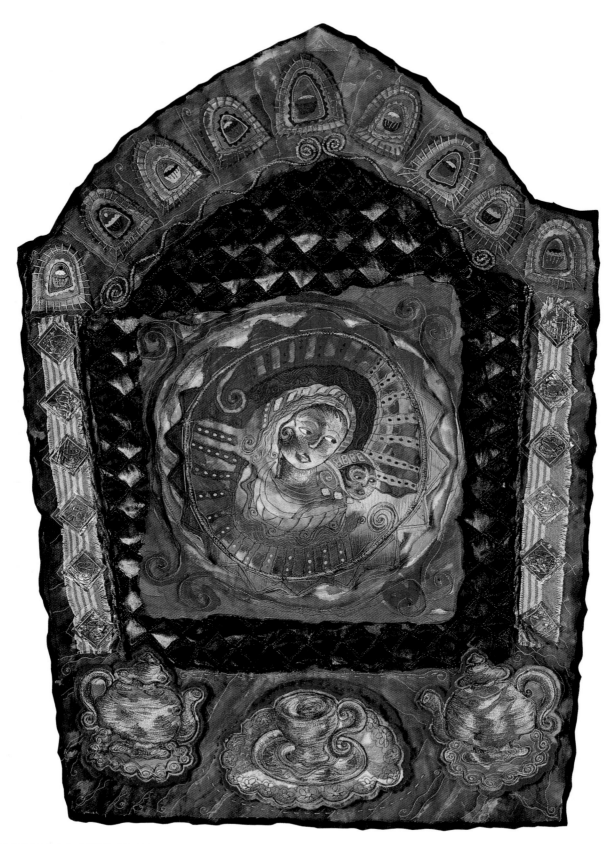

THE GODDESS OF AFTERNOON TEA
56 cm x 80 cm (22 in x 31¹/2 in)

THE SPIRIT OF COLOUR

CELIA PLAYER

SAM PLAYER

Colour is everywhere in Celia's world. Her studio is festooned with fabric swatches, blazing with the vivid colours which are her trademark. 'I make no apologies for working decoratively,' she declares. 'Decoration, colour, pattern and texture are my passion. I love to decorate myself and my environment, so it is a natural progression to decorate my work, or for my work to be decorative. Pattern is an integral part of everything I do.' The colours Celia uses are not the subdued pastels of her English homeland, but the blazing tropical hues seen under a clear Australian light. The colours of her wallhanging 'The Goddess of Afternoon Tea' are almost incandescent. The combination of yellows, oranges and reds, combined with velvety tertiary purples, emits a warmth for the soul at the same time as it provides a feast for the eyes.

Growing up in a creative atmosphere where both her grandmothers were textile 'fanatics' and both her father and grandfather were artistic, certainly contributed to Celia's love of textiles. 'I remember sitting on my grandmother's lap while she treadled her old sewing machine. She was the first person to put a needle and thread into my hand. My other childhood passions were drawing and paper dolls. Armed with paper, paint, pencils and crayons, I made endless combinations of paper dolls' clothes and was thoroughly content.'

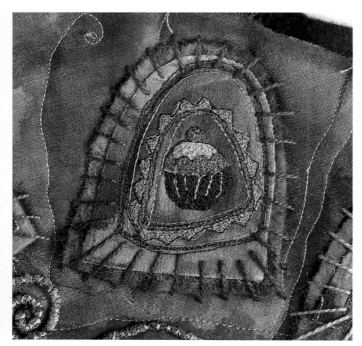

Whimsical little cupcakes are layered over fabric and hand-made felt, and hand-stitched to the border.

After leaving school, Art school was Celia's goal. She finally achieved this while working as a cleaner by day and a barmaid at night, until she had the requisite exams and qualification for entrance. Teacher training and Art and Design courses followed, interrupted by marriage and babies. While pregnant with her second child in 1978, she saw a machine-embroidery demonstration at a local community class. Celia was excited to discover that the freehand stitching, which she'd previously used only to darn the family's clothes, now could be used to decorate them, and in no time she had completed an embroidered dress for her small daughter. The enthusiasm soared, and soon Celia and a friend were designing a range of embroidered children's clothes for sale. Further studies followed. Then, while completing a City and Guilds Embroidery certificate, Celia met Belinda Downes, a well-known English embroiderer, and finally realised the full creative potential of her sewing machine. Celia eventually graduated with a BA (Hons) degree in Art/Embroidery from Loughborough College of Art in England. Now living in Sydney, she draws with a sewing machine, continuing a love affair with art that began in those early years.

Celia's current methods of working draw on many of the skills learned in Art school and which she still shares with her students. She draws inspiration from a variety of still-life objects, perhaps treasured pieces from her own collection, which are grouped on a pyramid of stacked boxes, draped with the brilliant fabric swatches she loves. Walking into one of Celia's classes is like entering a magical world, where no-one could fail to be enthralled and excited with the vibrating colours and intricacy of the patterns on display. Utilitarian articles, such as cups and

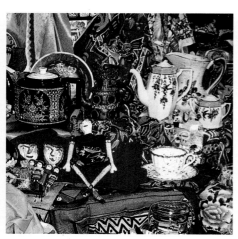

Celia begins with a 'still-life' collection which incorporates the colour, vitality and feel that she is aiming for in the particular work. Details of this still-life are photographed and recorded.

In the first stage of the drawing exercise, Celia uses a cardboard viewer to mask areas of the photograph and isolate the areas she wishes to use. The image is then drawn onto a section of a grid.

The completed series of drawings from the still life are photocopied and enlarged.

Elements from the enlarged drawings are cut and manipulated to achieve the desired effect.

Parts which will appear in the final design are isolated.

The enlarged photocopy is traced onto vanishing muslin.

saucers, take on a new significance when they are presented in this way.

Many influences combine to produce the images Celia creates today. An English childhood surrounded by Gothic and Elizabethan architecture; a later visit to India, where she absorbed the colours, decorations and ancient architecture; and finally, a move to a new country, with its own Aboriginal patterns, tall trees and different cityscape.

THE GODDESS OF AFTERNOON TEA
Conceptualising the Design

In 'The Goddess of Afternoon Tea' Celia was exploring the concept of everyday objects and how their practical and spiritual functions relate. She began with numerous sketches of areas of pattern and texture within the still-life arrangement, using a viewfinder made by cutting a rectangular window in a piece of card. This technique of framing part of a view is an effective way to direct the visual focus, as it removes the surrounding distractions. It's also an exercise often used by art students who find it is much less threatening to cope with only a small part of a much larger subject. The window can be held up to view a distant subject or be placed directly on top of a subject, or an area of pattern or texture.

Celia advises her students to work in only three tones at this stage. The darkest are drawn in black, the lightest is the white page, and the mid-tones are rendered with fine black lines and dots. The resultant

sketches are grouped on a gridded page. Numerous photocopies and enlargements are made, so the images can be rearranged, manipulated, and played with, as part of this early process.

'This is where the ideas start to appear – through the experimentation with this process. When the time comes to translate the ideas into coloured fabric, those first black and white drawings are a useful reference – the black areas relate to the darker fabrics and thread, and the lighter areas

Celia seals and crinkles the edges of the sheer fabrics by burning them with a soldering iron or a candle.

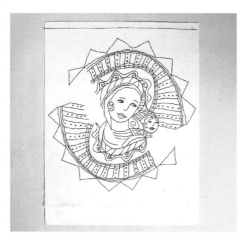

At this point Celia makes changes to the features and the design is reversed.

Transparent fabrics are layered on the muslin and the outline is stitched from the back. More stitching is added from the front, and pieces are added or taken away. The outline is cut to shape.

The fabrics for the background are layered and stitched in a free-flowing grid. The top layer of fabric is cut away between the stitching lines revealing the rich colours of the fabric beneath.

become paler fabrics and threads. This way, the design will continue to work and remain balanced.'

Creating the Goddess

Following this initial drawing stage, Celia traced her central goddess motif onto vanishing muslin, a heat-sensitive, stiff, open-weave cotton fabric which crumbles away into a fine powder when it is ironed. The design was drawn with a fine, waterproof, black pen so it will be clearly visible from both sides. A selection of transparent fabrics were layered on the right side, with a bright coloured satin on the bottom layer, then a patterned chiffon, and finally, a layer of hand-painted silk georgette.

Celia first stitched the outline of the drawing from the wrong side, then added further embroidery and embellishment from the right side, where the design was now visible. Extra scraps of fabric were added as required, and excess fabric trimmed away. This fluid work with colour echoes the ease with which a painter moves colour round a canvas, adding and subtracting as necessary.

The Perfect Background

Celia backed the lush velvet background with vanishing muslin overlaid with a dark, sheer fabric, before she stitched it in a freeform grid pattern, using free-hand embroidery. Alternate squares were cut away,

and the square outlined with a metallic thread. Then, with courage and skill, Celia took a soldering iron or a candle to her work to lightly singe the outside edges to seal and crinkle them.

The arched background shape that gives the work the feel of an icon was another layered construction. Canvas, coloured with acrylic paints, was covered with the same painted silk georgette as the central motif and backed with a layer of royal blue felt. Surface stitchery by hand and machine quilted the layers together.

A Touch of Whimsy

Celia definitely believes that too much pattern is almost enough, so the outside quilted frame was further embellished with wonderfully whimsical teapots, cupcakes and cups and saucers — all rich with swirling curlicues and still more glowing colour. The matte brilliance of hand-made felt peeps out from behind these shapes, adding to the low-relief effect. Hand-made twisted and stitched cords spiral down the sides. The whole effect is that of a precious, Byzantine devotional icon, and it's only a close inspection that reveals the marvellously subtle humour at work here, presenting all the trappings of a minor social event as a religious image.

Celia's home and studio are specially important places for her. 'My home is a woman's place. It's

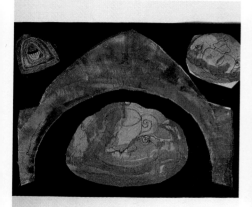

Dyed and painted sheer fabrics are layered over a variety of dyed and painted firm fabrics to create the background for the final design elements and stitching.

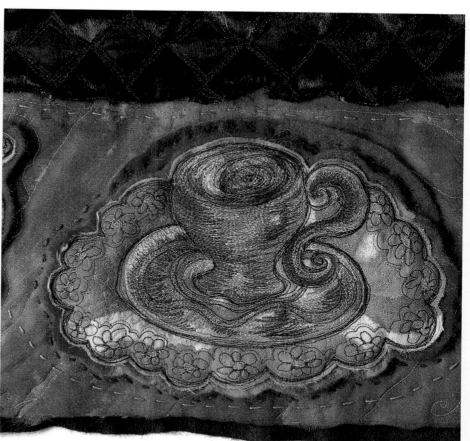

Celia has outlined the applied motifs with simple hand-stitching.

fragile, but secure. A house has compartments as life also has its compartments. These are more architectural elements, but I'm considering them in a more conceptual way now, using elements from the home with an architectural quality. I'm currently exploring images of everyday objects, and the spiritual context in which they are placed, such as a cup of tea which can be a reward or a comfort for grief. The fact that all over the world, there are people participating in this ritual fascinates me. Freedom within a structure is the way I like to work. My "Goddess" reflects all these influences.'

THE LAST TOSS
109 cm x 114 cm (43 in x 45 in)

A UNIQUE AND PERSONAL VISION

ALVENA HALL

ROBERT HALL

Alvena Hall brings a lively intelligence and a fierce curiosity to her art. Her views on everything from feminism to textiles are challenging and outspoken, and delivered with passion and an unrepentant sense of humour. She is fascinated by science and philosophy, and much of her work combines elements of technical processes, such as cyanotype printing and phototransfer onto fabric, with more traditional techniques such as piecing and quilting, to create unusual and haunting images. Alvena completed her Master of Arts degree, in Visual Arts in 1988 after initially training as an Art teacher. Her life is a busy and creative mix of working as a freelance textile artist, educational and sewing consultant to Bernina

in South Australia and a regular contributor of articles to textile and embroidery publications. As if all this wasn't enough, Alvena says that in her spare time, she runs a household of four people with very complicated lives!

Alvena has been exhibiting and selling her work at solo and group shows in Australia and New Zealand since 1979, and has had many articles published in magazines and calendars, including the cover of *A Sense of Place* by Jerry Rogers, a collection of works by Australian embroiderers.

Extensive travelling to teaching engagements takes Alvena through many isolated areas of rural South Australia, and her camera is always ready to

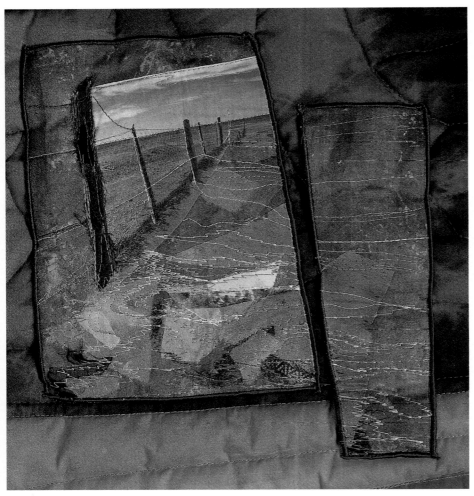

Alvena has enhanced the colours of the photo-transferred images with freehand zigzag stitching.

capture ideas which she uses in her work. One recent series of large quilted wallhangings, 'The Fragile Zone' examines the emptiness of space in the Australian outback, where rusty abandoned cars, crouching like enigmatic sphinxes dominate a surreal landscape of endless sandhills and hot blue skies. She is continuing to explore lace-making techniques in a collection of veils, mysterious ritual garments that conceal and reveal simultaneously.

To Alvena, being a visual artist means that the act of seeing is of immense significance, and her artist's eye is consciously looking, noticing and recording images, with drawings or photography.

'Colour is a big thing for me and I've been dyeing fabrics and threads since 1980. Photography is now of critical importance as it provides the source imagery for most of my work. Drawing is

White homespun was painted this lovely soft earth colour while the black fabric was discharge dyed.

Patterns in the cracked, parched earth were the inspiration for the quilting design in 'The Last Toss'.

A colour, mirror-image photocopy of the photograph was made onto Magic Paper.

like doing your scales in singing or piano; it's the five-finger exercise of the visual arts and needs to be practised daily; it's the origin of the images that haunt your mind until they eventually find expression in the work.'

These collected ideas and impressions are the springboard from which Alvena launches into explorations of concepts that may result in a whole series of works.

'I keep a journal and cart it about with me everywhere. I tear bits out of the magazines at the dentist, draw doodles on the back of dry-cleaning slips and glue them in and draw over them and redraw them and add a few photographs. I suppose this is one way that ideas are born. I scrawl notes and stitch directions, then have a huge problem deciding whether the idea is a Big Idea for a metre (a yard) square work or just a little idea for embroidered notepaper.

'Sometimes there are whole clusters of ideas — flight and flocks of them like galahs in a wheat paddock. These I keep all together and when the time comes to do something about it all, I will have three or more works on the go at once. That is a great way to work. I assemble fabrics and photographic images onto a canvas ground in much the same way that a painter assembles colours and forms. Everything is subordinate to the mood or the image that is being created. Great subtlety of colour is the key and I have learned to produce the coloured fabric I need by dyeing and painting.'

DYEING FABRIC

Alvena uses several different methods of colouring fabric. One fast and easy method is the 'cram-jar' technique, which can be used with simple household dyes, such as Dylon, or domestic bleach.

Cram-jar Dyeing

In this method, the cotton fabric is first washed to remove any chemical sizing. This step is especially important if you are using calico, which may require several washes. As the fabric needs to be wet to accept the dye, after washing it, Alvena wets it again in a bucket of warm water to which she has added a drop of dishwashing detergent, then squeezes it out.

Now it's time to mix the dye solution, following the manufacturer's instructions. Alvena uses common household dyes for this technique and always wears gloves and a mask to prevent her inhaling the poisonous dye powder. She warns, 'Never use food preparation utensils to mix the dye and avoid doing it in the food preparation area.'

You will need a good-sized screw-top jar for the next part of the process. A large coffee jar will hold about two metres (two yards) of fabric. Half-fill the jar with the dye solution, then stand it in a sink or

The photocopy is laid, face down, on the fabric and pressed for thirty seconds with a hot iron, before the paper backing is peeled off. This picture shows the backing partially removed.

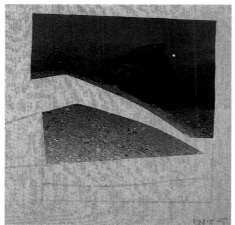

The image is cut, rearranged and dislocated, then it is attached to the painted background with fusible web. The composition lines are drawn ready for the embroidery.

Alvena suggests practising lines of the letters e, f and m, then the alphabet. See how the letters look if they are linked and if they are separated. Experiment with variations of colour and texture.

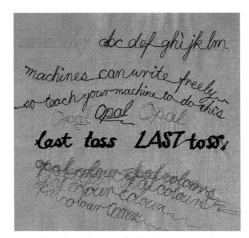

Practise the slope of the letters and how they will look on a curve. Experiment with different threads and stitches until you find the combination that works best.

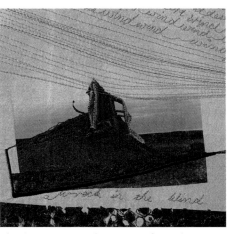

The image was phototransferred directly onto coloured fabric. Text is used both for readabilty (centre) and for the textural effect (upper right).

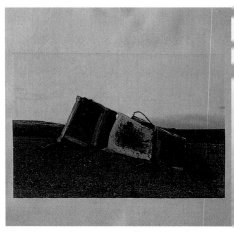

Phototransfer is very effective when made directly onto coloured fabric.

bucket and, wearing rubber gloves, stuff the wet fabric tightly into the jar. Replace the lid and shake the jar gently to bring all the air bubbles to the top. Leave it for about ten minutes, then remove the fabric. Dissolve a tablespoon of salt in the dye solution, before replacing the fabric in the jar. The salt forces the dye out of the solution and into the fabric. Shake the jar again, then let it stand upside down for at least ten minutes, or longer, depending on the colour effect desired.

Finally, remove the fabric from the dye, rinse it at least three times, then wash it with soap before rinsing it well for the last time.

Discharge Dyeing

In this method, colour is removed from fabric using diluted bleach. Begin by testing a dyed cotton fabric with a little diluted bleach. If the result is pleasing, mix up a solution of one-third household bleach and two-thirds warm water. Fill a jar half-full of the

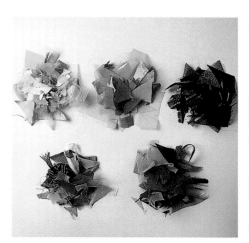

A selection of fabric fragments, including silks, plain and printed sheers, taffetas, satins and organzas, were organised by colour.

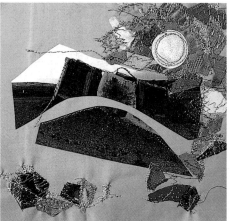

The confetti fabrics were secured with super-stretch stitch, using contrasting as well as toning threads.

The background fabric has been painted with much-diluted fabric paints for subtle colour shifts. On the left, tiny fragments of fabric are caught with free machine embroidery. On the bottom right, larger pieces of sheer fabrics are pinned before being stitched.

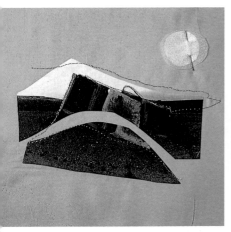

The image was phototransferred onto cream voile which was cut up and displaced on a blue background. Just enough stitching was applied to hold it all in place.

bleach solution and push in the wet fabric. Shake the jar, then let it stand for about ten minutes. Shake it again and let it stand, inverted this time, for another ten minutes. As warm bleach works faster than cold bleach, you can stand the jar in a hot water bath in cold weather to encourage the process.

Finally, rinse the fabric well. Black, navy and bottle green fabrics often discharge with very surprising results because of the different-coloured dyes which were used to obtain the original colour. For example, black fabric can discharge to reveal flashes of red.

Never use undiluted bleach because it can eat holes in the fabric.

THE LAST TOSS QUILT

The Inspiration

'The Last Toss' was conceived when Alvena stopped in Coober Pedy, an opal mining town on the edge of the desert, where water is more costly than beer.

'There are brutal vertical surfaces where the bulldozers have been busy and even more brutal vistas of desert. The sky is a relentless heavy blue or else solid with dust at every puff of wind. With

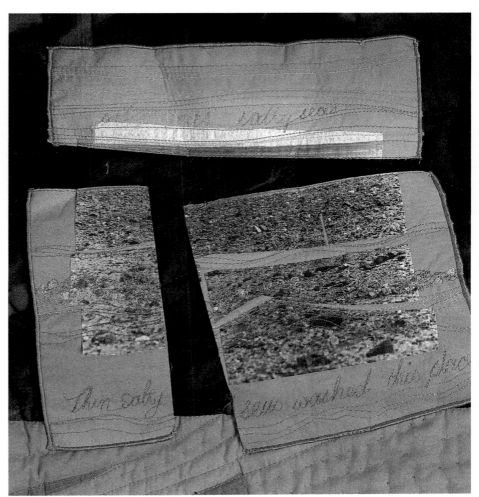

The pale threads used for the stitching in the sky area suggest the emptiness of a windswept landscape.

outside temperatures often over 40 degrees Celsius (104 degrees Fahrenheit), there is a glare powerful enough to make you weep, and a silence as black and heavy as rock inside. There, on top of a mullock heap, at the edge of town, I found a wrecked car, a poignant testament to a miner's last ditch effort to find the elusive "colour" of the highly-prized opal. As the light faded, I photographed everything furiously, dancing about amid shards of smashed beer bottles. Lots of notes and thumbnail sketches later, I produced the final design. The central image would be the wreck on a mullock heap, surrounded by a mosaic of other fragments, with the pictures I'd taken phototransferred onto coloured fabric, and attached to a wide border quilted to resemble cracked clay.'

The Materials

The search for just the right materials to bring her vision to life sent Alvena scurrying back to Adelaide and her fabric collection, looking for the soft, bleached apricot for the mullock heaps and the heavy blue of the early evening sky. A cram-jar dyeing session produced some serendipitous results, with flashes of lighter colours among the darker shades, destined for background areas in the border.

Creating the Image

Alvena makes great use of photography in her work – both as a record and also as an intrinsic part of the created work. For best results when copying photographs onto fabric, she advises using clear images, strongly contrasted against a simple background. The fragmented landscapes surrounding the wrecked car were copied in mirror image onto transfer paper, called Magic Paper, which was fed through the photocopier by hand. For skin tones, the copy needs to be a few shades lighter than normal for good colour. She then trimmed the edges off the photocopy and laid it face down on the fabric. To transfer and set the image, Alvena pressed for thirty seconds with a hot, dry iron at the hottest temperature that the fabric could stand, then immediately peeled off the backing paper and trimmed the excess fabric.

To emphasise the fragmentary quality, she slashed and spread the pictures, before attaching them to the dyed background fabric using fusible web.

Words and Pictures

Alvena often uses text in her works, to create areas of linear pattern on the fabric or as a clearly legible image which conveys a message. 'The way in which the words are written can enhance the impact of the message, so it's worth trying several different lettering styles until you find one that is easy to do and gives the desired effect. Automatic lettering built into the sewing machine is easy to use, but the style may be too mechanical for the rest of the work. Experiment first, trying automatic letters and different types of freehand script on fabric fused to firm interfacing.' Letters can be written along neatly ruled lines, flowing curved lines or used to fill in a shape, with size increasing or decreasing as desired. Choose the colours for the letters, deciding whether to have a strong contrast or a subtle effect where the letters blend into the background. Zigzag can be very effective and bold, and can look different depending on whether it is worked straight or at an angle. Alvena played around with all these possibilities, before finally deciding on the freehand script she used, emphasising the concept of a windswept sky and the salty sea that once covered this now desert area, and where opal formed along what was once an ancient shoreline of a shallow inland sea.

Texture, Texture, Texture

To suggest the surface textures of the mullock heap, Alvena snipped a large variety of fabrics into small confetti-sized scraps and sorted them into piles of different colours. Each individual scrap was precisely positioned with tweezers, then free-machined into place, using a wide stretch-stitch pattern. 'Leave some of the background fabric showing,' Alvena cautions, 'as this is an essential element in the design. The important lesson to learn here is that colours change according to their relation to other colours, so thread colour is significant. It can match and fade into the background, or create a subtle counterpoint over the contrasting fragments. My aim was to capture the natural flickering lights found in opal.' Drawing a parallel with the dinosaurs, Alvena takes the inspiration even further: 'Given aeons of time, just imagine that wrecked car decomposing, the silicon invading the space it leaves, to become an opalised car!'

By quilting the assembled images over cotton batting, Alvena drew the whole together. Referring to photographs of dried and cracked earth, she quilted a network of freehand lines to reinforce the idea of a parched landscape.

The Final Touches

Critically observing the final result, Alvena checked that the balance was correct. She added a few larger pieces of pink organza and other sheer fabrics and quilted them into place with some tiny satin-stitched beads. 'Be sure to keep looking at the work,

watching the colours become friends, or go all cold and dark as you sew. Believe me, this is the BEST fun,' says Alvena, making light of many hours of sewing and creative decision making. 'The truth is that none of the things I actually do are all that complicated. Mostly, the technical side of creation is dead simple. It isn't what you do, rather it's how it is done, in a certain context.'

With her customary energy Alvena pushes her students into creativity. 'She who never made a mistake never made anything,' she insists firmly. 'The big thing is not to stare at the sunset. The big thing is to produce, produce, produce and make millions of mistakes. That is how you learn. Ruthlessly edit your own work. Just because it took a hundred hours does not mean that it is any good.' However, the hundred hours and more invested in 'The Last Toss' proves that in the hands of this artist, it is very good indeed – a haunting and evocative tribute to the beauty of a relentless and unforgiving landscape.

Small scraps of fabric, like confetti, are attached with freehand zigzag stitching to suggest the natural flickering colour and light found in an opal.

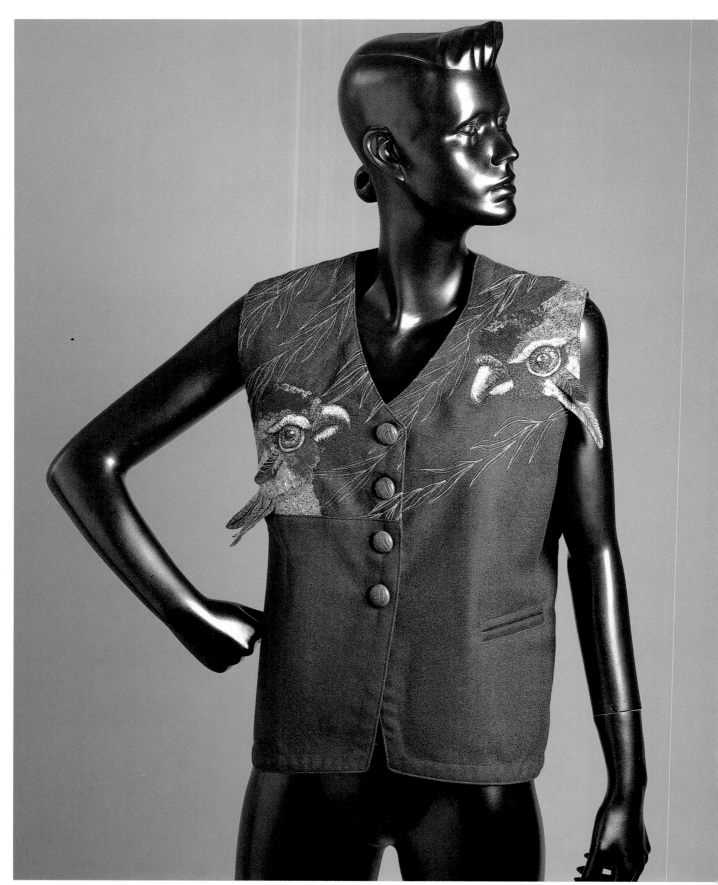

THE PARROTS VEST

DRAWING AND DREAMING

CHERYL BRIDGART

CARMEL BRIDGART

Drawing, using a line to record dreams, ideas and feelings, has always been an essential part of Cheryl Bridgart's life. 'As I'm not a writer, I express myself visually, so my drawings are very important – they're like personal diaries. I draw at home, in my studio, and sometimes at night, if I awake from a dream. Even now, a day does not go by that I don't create a drawing, which is then somehow interpreted in machine stitching.' Drawing is the starting point for all of Cheryl's work. In her hands, the sewing machine becomes a drawing tool, creating lines and blending thread colours with accomplished ease and sensitivity.

'As long as I can remember I have drawn, painted and sewn. I have vivid memories of finding inspiration in my grandmother's magazines, which I translated into drawings and designs for my dolls' clothes and stitched on a child's sewing machine, using scraps from my mother's dressmaking. Later, I progressed to designing and constructing garments for myself and decorated them with beading, appliqué and painting. I further enhanced the surface with machine embroidery. Some of these early pieces were quite over the top and a challenge to make. There was never enough time to create them all.'

Moving from teaching Art to practising Textile Art in 1988 seemed a natural progression. Drawing

Once the wool fabric is fused to the backing, the freehand design of flowers and foliage is stitched. Only a straight stitch is used, but the thread colour varies.

For the tiny feathers on the bird, minute scraps of fabric are cut and held in place with a toothpick, until they are fixed in place with feather-shaped stitchery.

and sewing merged, as the challenge to create realism, details and expressions using the sewing machine found expression in a series of intricately detailed embroidered portraits, which were shown at Cheryl's first solo exhibition. Faces, figures and animals have continued to feature in her work, often combined with stunning effect on the meticulously finished creative clothing for which she has become well known throughout Australia.

Many of Cheryl's working methods stem from her early experiments on a very old sewing machine. 'As I was self-taught, I did not use a hoop as I thought hoops were for handwork! The feed dogs could not be lowered on my old machine and I was not aware that they should be covered. I think I eventually wore them away! I held the fabric firm with my hands as I did not use any type of stabiliser. By removing the sewing machine foot, I found that I could move my fabric in any direction, giving me complete freedom to draw with the needle.'

Cheryl set herself strict rules early in her career, and never draws outlines or marks her fabric in any way before beginning to sew. 'The needle had to become my new pencil. A single line of stitching begins each work. Using my designs and coloured drawings pinned on a board behind the machine as reference, I work only from live subjects or my own imagination – never photographs. With every new colour threaded onto the machine, my works become more alive.'

THE PARROTS VEST

The whimsical animal and bird figures often featured in Cheryl's work are the result of many observation and drawing sessions at Adelaide Zoo, combined with imaginative treatments often derived from dream images. The feathered effects shown in her Parrot Vest combine fabric collage with freehand embroidery to create a rich and jewel-bright surface. The birds are outlined in a neutral shade and the leaf shapes are stitched in dull and darker colours, forming a subtle background which does not detract from the vitality of the subject. By stitching quickly, and moving the fabric smoothly, Cheryl outlines the leaves, then fills them in.

Beginning with Good Design

Cheryl begins by sketching the design and usually more than one. Here she plays with the shape, cut and proportion. When she is satisfied, Cheryl moves on to draft the pattern, adjusting and pinning until she gets it just right.

Next, if the design is complicated, she makes a calico toile or sample garment.

The fabric for the vest, a fine wool, was selected and a stabiliser was basted to the back. The pieces were cut larger than the draft pattern, because the embroidery causes them to shrink. This safety margin also gives Cheryl more flexibility to play with the final placement of the embroidery.

Machine Embroidery

The texture on the bird's body was made up of dozens of tiny squares of silk, which were held in place with a toothpick while they were freehand stitched with a little of the background colour showing through between the shapes. By varying the spacing and the density of the stitching, some areas became more prominent, adding a fluffy, feathered texture to the surface.

When the embroidery was completed, the pieces were cut to the exact pattern shape and assembled.

Three-dimensional Feathers

The three-dimensional feather shapes are lined so that they will keep their shape well during wear and cleaning. Cheryl pins the silk to a lightweight lining fabric and stitches in a feather shape, before she trims the piece and turns it right side out. As each feather is made individually, several threads are attached to the point of the feather, to act as a handle so the piece can be moved more easily under the needle. Both sides of the feather will be visible, so Cheryl chooses the bobbin colour as carefully as the top thread. After stitching the edges with a small zigzag, she free-stitches the centre of the feather. Tiny touches of other colours may be worked in, before the feather is stitched in place.

The three-dimensional feather shapes are cut from silk and sewn together. Turned right side out, they are given a handle of long threads to make them easier to manage during the embroidery. Finally, a lacy tracery of feather shapes is sewn down both sides.

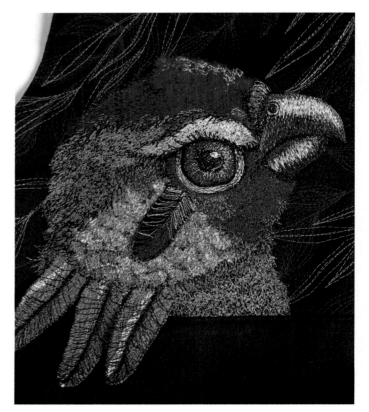

THE PARROTS VEST
Detail of a parrot

THE PALETTE

The colour palette of threads that Cheryl uses has gradually diminished, as she draws on a colour theory utilised by Impressionist painters such as Claude Monet. 'More and more, I'm finding that I can create new shades by the placement of certain colours side by side, or over each other. A new colour is then mixed optically. When I started, I never seemed to have enough threads to choose from. Now, I use less, but mix them more to create endless colours with the stitching and crosshatching of threads. Sometimes, altering the top tension to allow the bobbin thread to be partly visible can create rich effects.'

EXPANDING THE VISION

Every innovative and individual garment is unique, as Cheryl designs and drafts each pattern to suit the embroidered image. 'During the designing stage, I look at the overall balance of the elements to be embroidered and the garment form. The cut, the shape of a seam, a hem or a sleeve may be influenced by these elements. In one early work, a fish dress, the sleeves were fish-shaped and the hems were fins! I sometimes focus on areas I wish to accentuate on the garment and this will influence the embroidery. I try to create a balanced, decorative and aesthetically pleasing garment which will also be comfortable, wearable and unique.'

Experimenting with different construction methods leads to some interesting discoveries. Inspiration from masks seen during a recent visit to Venice, resulted in coats and vests with seams shaped to the profile of a mask, with beautifully finished holes for the eyes. An important recurring theme is that of windows, which Cheryl sees as 'a window to my inner or dream world. Sometimes the windows are filled with embroidered images, or eyes, sometimes they are mysteriously empty.'

Cheryl is passionate about originality, careful execution and a meticulous finish. Her favourite fabrics include linens, wools, suiting and velvet, which she fashions into elegant clothing.

THE ZEBRA SERIES

Her work often has a special touch of gentle humour, as in the 'Zebras, Where?' collection, decorated with tiny embroidered zebras, cheekily kicking their back legs, peering out of pockets or disappearing into seams, leaving only a striped tail or an ear showing. A matching range of animal portrait handbags, exquisitely stitched with huge soulfully fringed eyes and delicate ears sold out in a flash, snapped up by discerning buyers.

The zebra series was based on images captured from a dream – beginning with rough drawings, then detailed drawings. In 'Zebra Dreaming' the zebras with their cheerfully kicking legs surround and intrude on the dreamy faces. 'For me, the zebra is a happy symbol that has appeared to me in my dreams when things are going well.'

Cheryl began stitching on a piece of unmarked canvas, sketchily stitching parts of the images until the entire work was covered with crosshatched lines of thread which create the colour pattern, details and movement. The zebras are embroidered in a free naive style 'as they are fantasy creatures from a dream world'.

Cheryl's technique is unique among Australian textile artists in that she uses only a simple stitched line as the primary element in all her work. By varying the colour of this line, she is able to create dramatic illusions of three-dimensional forms as if she were using paint or pencils. The imagery is intensely personal.

Her work has been featured in every Art To Wear exhibition in Sydney since its inception in 1994, and has been shown in two Bernina International calendars. As well, Cheryl has participated in many group and solo shows. She also conducts workshops throughout Australia.

'I think my work is becoming more personal. I'd like to move into more three-dimensional work and sculptural forms in the future, and further develop my window imagery. I'm still not tired of stitching – it's an obsession.'

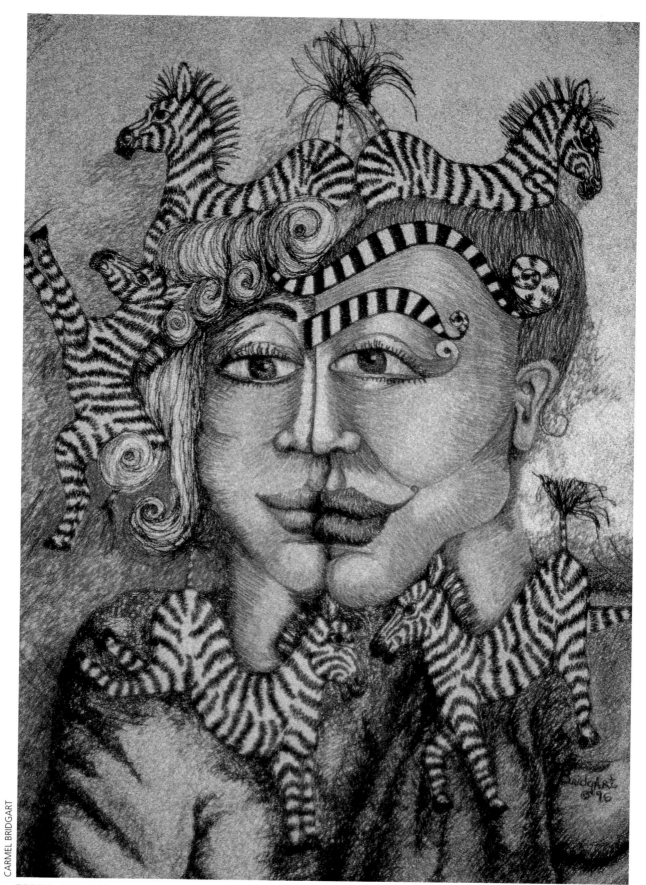

CARMEL BRIDGART

ZEBRA DREAMING
46 cm x 71 cm (18 in x 28 in)

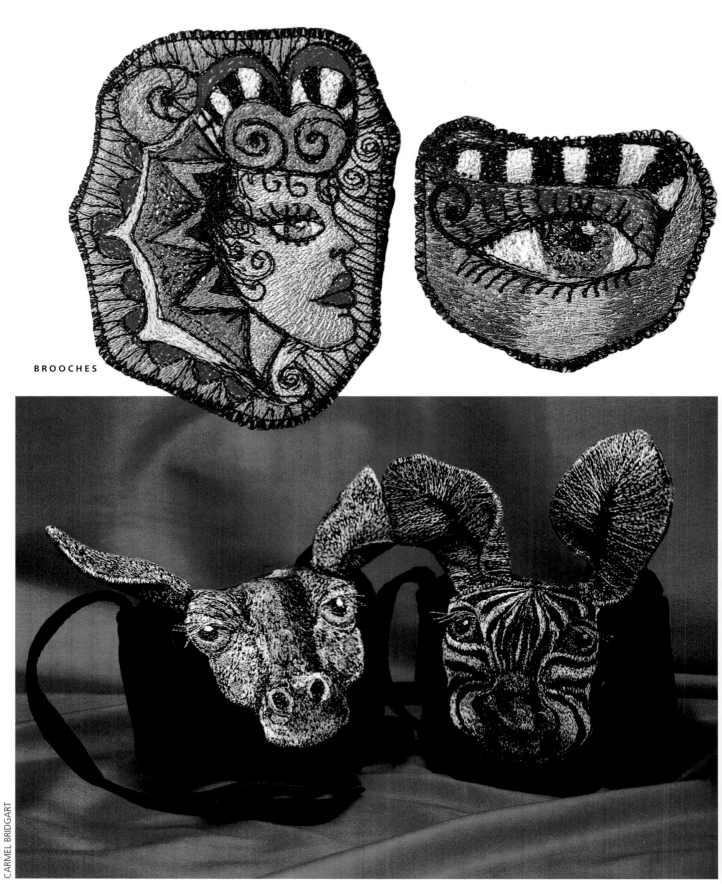

BROOCHES

CARMEL BRIDGART

ZEBRA BAG AND GIRAFFE BAG

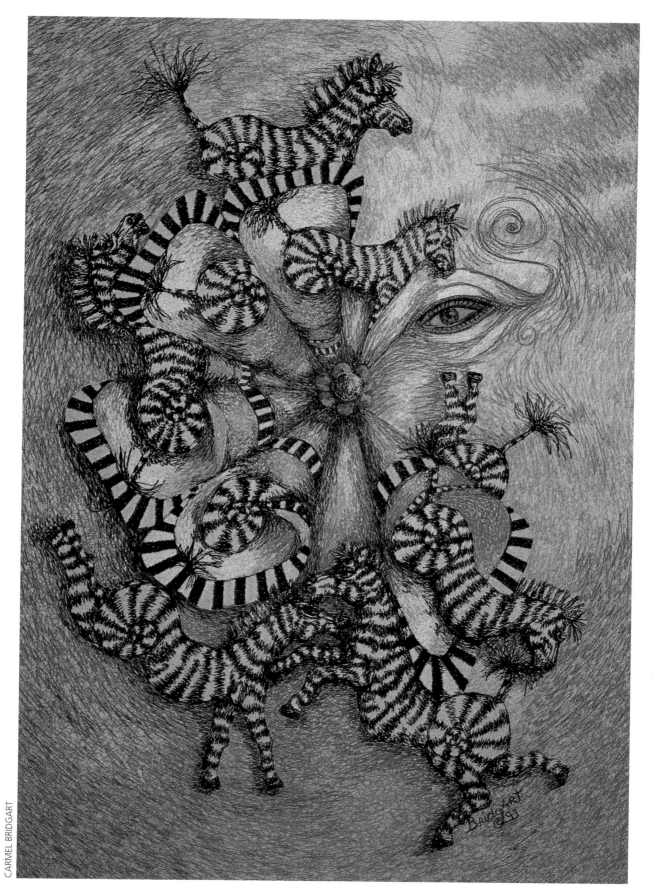

CARMEL BRIDGART

SPIRAL ZEBRAS
46 cm x 65 cm (18 in x 25 1/2 in)

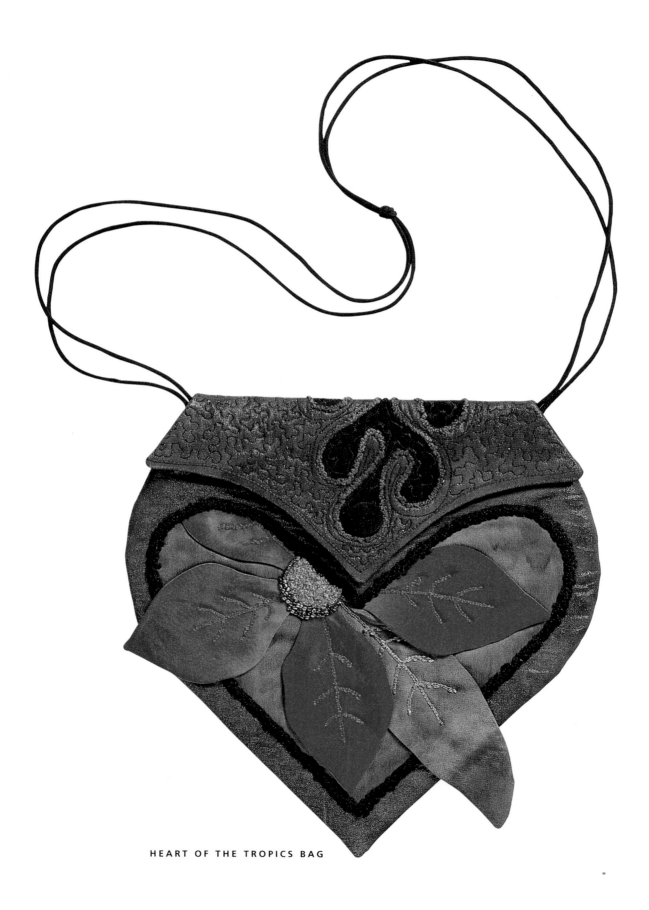

HEART OF THE TROPICS BAG

A PRACTICED PERFORMER

KEN SMITH

CLAIRE AUSTIN

'Have machine, will travel,' says Brisbane-based textile artist, Ken Smith, who teaches classes in silk painting and creative machine embroidery anywhere he's asked to go.

Ken discovered machine embroidery as an expressive art form, while teaching English, History and French at Chesham High School in England. He learned basic sewing skills early on an old Singer treadle machine. 'When I was twelve, my grandfather, who had been a sewing machine mechanic in London before the First World War, said to me, "Come on, I'll teach you to use a sewing machine, you never know when you'll need it."' It proved a useful skill for a child with an interest in costume and theatre. Ken progressed from making costumes

for childhood shows under the house in Cairns to those for the winning Horse of the Year Quadrille in London, professionally produced pantomimes and school productions. Colour, pattern, texture and finish have been a creative release about which Ken has become passionate.

While living in England, Ken did workshops with Constance Howard – a legend in English embroidery circles – which contributed valuable technical experience. He bought a machine and continued practising. 'My first machine was a secondhand Singer Featherlight. I couldn't lower the feed dogs, so all the work had to be linear, and I had to move the fabric rapidly in order to draw. It certainly taught me to work fast!' Freehand machining is still Ken's

favourite sewing technique. 'I can sit and machine embroider for hours on end, without noticing the passage of time. However, anything involving conventional presser-foot work on the machine, like the dressmaking part, I find dead boring and have to force myself to continue.'

The starting point for most of Ken's works is plain white silk, which he transforms by dyeing, handpainting or with shibori techniques into glowing, solid, shaded or mottled colours, crinkled or smooth. Often the silks are layered with sheer or metallic fabrics to produce an enormous range of luscious surfaces, where the play of light enhances the precision of the embroidery. 'My work is decorative', he says, without apology, 'and mercifully lacking in the deep and meaningfuls. I hate it when any piece on display is accompanied by an explanation of personal meaning, social significance, genesis, etc. A work should speak for itself and be open to interpretation by the viewer.'

Ken attributes a good deal of the development of his personal style to the isolation of working in Cairns, where he returned to live in 1988. His colour schemes are unconventional, featuring reef and rainforest brights and his favourites since childhood, red, purple and black.

'Generally, I don't work to a classic Art-school method of designing, with trial samples in different styles, materials and layouts in paper or paint. I seldom do more than a few rough sketches, as a means of getting the design out of my head. I've a good visual memory and quite a sound spatial sense, so I don't feel the need to commit everything to paper. Besides, leaving options open makes the project more exciting and I really believe that working in this way enables me to develop a piece further than I would otherwise.'

A large studio in a warehouse five minutes from his home is set up with areas for silk painting and sewing. Production of the painted silks and threads, and commissioned works to meet the increasing demand from exhibitions and galleries, leaves less time for the continuing experimentation that Ken finds essential to add new techniques to his already extensive

Ken sews whipstitch with two threads through the needle, a very tight top tension and a slightly loosened bobbin tension.

Heavy thread mossing creates wonderfully rich texture. On the left, is the stitch pattern for a mossed line viewed from the back; in the centre is mossing between two lines; on the right is the finished effect on the front, stitched with a loose bobbin tension and a thicker bobbin thread.

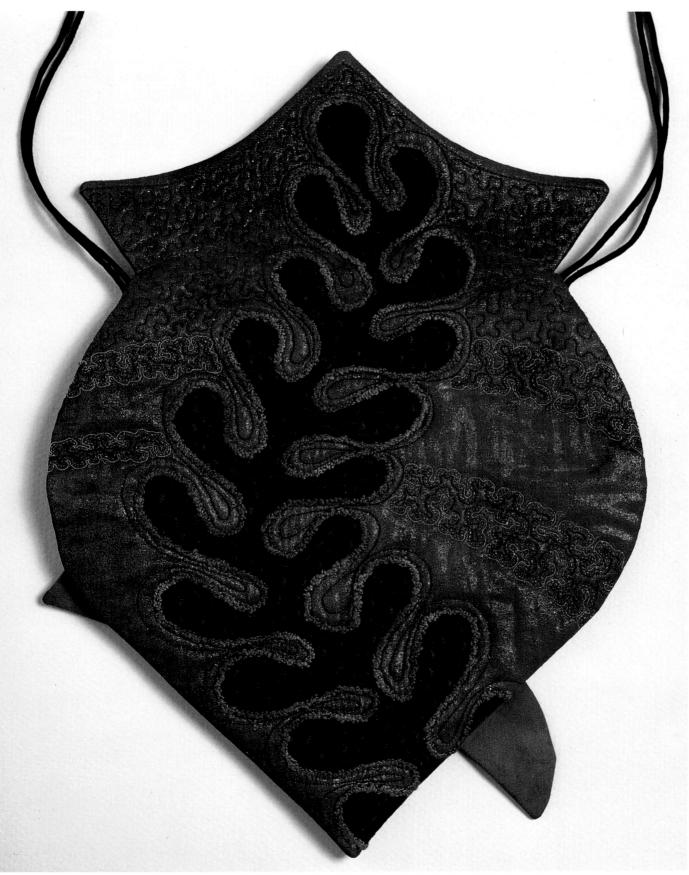

EART OF THE TROPICS BAG
ack view

repertoire. However, the odd hours are somehow squeezed into the day to create more teaching samples, which are themselves art works which would grace any gallery wall. One striking black silk vest is patterned with dozens of tiny inset windows, each containing an example of a different embroidery technique.

Being an accomplished silk painter means that Ken can paint any colour combination that is required for the beautifully finished garments and accessories for which he is well known. His preferred weight of silk is at least medium weight, (or 16 momme) and he often stabilises this further by ironing on a layer of fusible Pellon to support the fabric and add a slightly quilted appearance to the intensive embroidery which follows.

HEART OF THE TROPICS BAG

This gorgeous evening bag, which is so evocative of vivid tropical flowers, features a number of his favourite techniques – including reverse appliqué, mossing and meandering – all worked on hand-dyed silk.

The Fabric

Both the back and front of this bag are made from a 'sandwich' of painted silk georgette over gold lamé, which is backed with a layer of Pellon for padding, and a bottom layer of Vilene to add a firm base. First the Vilene is cut into rectangles at least 2 cm (3/4 in) bigger on all sides than the greatest pattern dimensions. These are then used as templates for cutting fusible Pellon, lamé and organza. The Pellon is fused to the back of the lamé and the organza is hand-basted into place. An additional layer of fusible Vilene is bonded to the back of the Pellon for extra firmness, before all the layers are machine-basted together.

Reverse Appliqué

The heart shape which is a feature of the front of the bag is created with a reverse-appliqué technique which Ken prefers to use because it reduces bulk when it comes to the embroidery.

To make the petals, pink silk was stitched to the blue backing silk. The seam allowance and the tip were trimmed, curves clipped and the petal turned through. Ken used a satay stick and gentle pressing to shape the petals.

The petals are attached to the insert panel with cable stitching, using an orange pearl cotton wound in the bobbin.

Ken first draws the heart shape onto the back of the Vilene, using a sharp pencil. He then stitches just outside the line and again just inside it. This way the first stitching line will be cut away and the second one covered when the appliqué is in place. He prepares the black insert in the same way as the bag.

The flower petals are individually bias-cut from a double layer of silk and stitched with a short straight stitch. Ken adjusts the shape of the petals using a satay stick and careful pressing. The veins on the petals are cable stitched from the back of the panel, using an orange pearl cotton in the bobbin and a polyester thread to match the petal, through the needle. The inner circle is also stitched, before the ends of the petals inside the circles are cut away.

Now, the panel with the petals is pinned under the heart-shaped opening, with the free ends of the petals folded and pinned out of the way. Ken sews three rows of stitching, 1 mm ($^1/_{16}$ in) apart, on the outer line of the opening, on the inner line to prevent the edge from curling, and on the panel, just off the cut edge. These rows of stitches fix the panel in place and serve as guidelines for the mossing. Next, Ken trims away the excess fabric from the insert panel, leaving an allowance of only 1 cm ($^3/_8$ in), before trimming the Pellon and Vilene very close to the stitching.

Mossing

Mossing, one of Ken's trademark techniques, gives a wonderful raised, bobbled line, and is used very effectively to outline the reverse appliqué on the front of the bag. For mossing, Ken uses a thicker thread in the bobbin and a colour-matched polyester thread through the needle. Mossing is worked from the back with a loosened bobbin tension so that the thread will 'bobble' on the front of the work. Ken recommends running the machine quite fast to ensure an even coverage.

Mossing is also used to outline the appliqué on the back of the bag, using a variegated pinky-orange silk yarn, from a range Ken dyes himself.

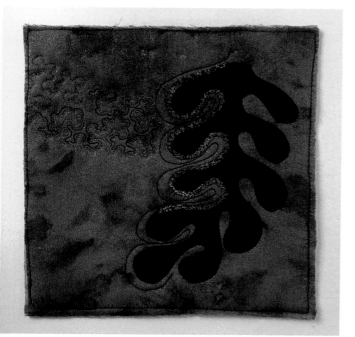

The edges of the black appliqué are covered with mossing. Three rows of meandering outside the appliqué add a quilted effect.

Ken works the three rows of meandering stitches from the wrong side of the work.

Whipstitch

The swirling black appliqué, which is a feature of the bag, travels across the back of the bag onto the front flap. The appliqué fabric is first backed with fusible web, before being cut out and fused over the lamé and georgette sandwich. The shape is first stitched with three rows of stitching: 2 mm(¹/₁₆ in) inside the cut edge, just off the cut edge and again 2 mm (¹/₁₆ in) from the cut edge of the background, before the whipstitch is worked. The subtle corded effect of the whipstitch is created by threading a size 100 embroidery needle with two threads of black poly-cotton, and the bobbin with black rayon, and loosening the lower tension slightly. The top tension is tightened 2–4 degrees. Using a freehand embroidery setting and working from the right side of the piece, Ken stitches in small meandering curves, running the machine very fast and moving the fabric very slowly. Working with two threads through one needle, and changing colours and bobbin threads, and top and bottom tension gives a wide variety of gradual and subtle colour changes, which complement the brilliance of the hand-painted silk.

Details

Fine detailing is no problem at all for Ken, who loves to work intricate fine lines in this movement he calls 'meandering', and which resembles Cornelli work and stipple quilting. Working on the back of the fabric, with gold thread in the bobbin, he stitches a wavy meandering line over the sandwich of padded silk organza, adjusting the top or bottom tensions, if required, so the gold thread lies flat and does not feather the top thread around curves. 'Any metallic or glitter thread which gives trouble when used through the needle usually becomes trouble-free when used in the bobbin, as there is little or no stress placed on it.' Ken recommends working from the back of the work, especially when following other lines closely or when working on dark colours.

The back of the bag was stitched in this way, with a second line of gold and a third one of dark blue echoing the first line of stitching. This looks good on any scale, in any degree of complexity. It also has a wonderfully high 'effort-to-result ratio', Ken adds with a wry grin.

The movement required to achieve this beautiful effect requires practice, but as Ken constantly counsels his students, 'Practise and experiment often. Build up your own vocabulary of stitches and techniques – the ones both you and your machine like. Play with samples, and record details so you can repeat them. Ignore inhibited purists who say 'That's not the right way to …' If it gives you the effect you want, then it's right, whatever they say! Ignore any rules other than those with a solid technical or practical foundation. Practice doesn't make perfection, but it certainly leads to improvement. It's not a question of difficulty but of practice and play. The more practice, the better the practitioner, the more ideas occur. Practice stimulates creativity.'

Ken describes his forthright views on the subject of machine embroidery as 'getting on his soapbox', but his students embrace his ideas with enthusiasm. 'The most exciting aspect of machine embroidery is its versatility. Once the notion of sterile and infinitely repeatable machine perfection, programmed motifs, single-layer embroidery and the 'right way' are discarded, then the possibilities for personal expression are limitless. Whatever your preferred style, it is achievable.'

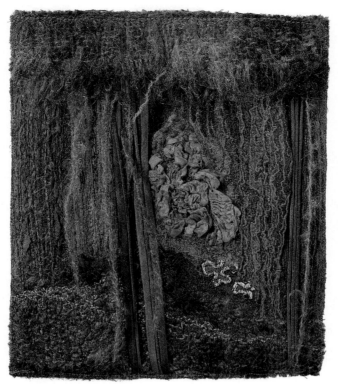

FUNGOID
19 cm x 23 cm (7¹/₂ in x 9 in)

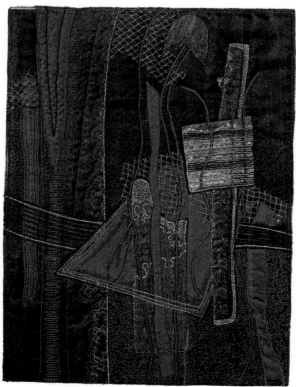

OFF THE FLOOR AGAIN
22 cm x 29 cm (8³/₄ in x 11¹/₂ in)

THE SEVENTH WAVE SCARF

A DEDICATED FABRAHOLIC

KRISTEN DIBBS

BOB PETERS, HIGHLIGHT STUDIOS

Art, English and Music were my three favourite subjects at school. Decades later, the preferences are much the same, but the painting is now done with machine embroidery and fabric, the music is an essential background to the creative process, and I love writing books and magazine articles on machine embroidery.

Most of my life seems to have been spent teaching creative subjects. If I'm enthusiastic about something, I want to share it with others and, for me, writing is another form of educating, communicating and sharing. Maintaining a profile as a textile artist, tutor in machine embroidery and author keeps me challenged, busy and fulfilled.

I was originally trained as a primary school teacher, then completed further training at the National Art School, and by the mid-1980s, I was a lecturer in Art Curriculum, showing teacher trainees how to teach Art and Craft to primary school children. When I purchased a new Bernina 930 machine in 1986, it opened up unlimited and thrilling creative possibilities. I went to all the classes at the machine shop and hungered for more. Each week, I'd borrow another five or six books on textiles and machine embroidery from the college library, and work through as many ideas as I could. Much of my time was spent exploring, and by playing, fiddling and following new and exciting directions, I discovered a

lot of unusual and interesting techniques that could be achieved with a sewing machine, and applied to artworks, garments and accessories.

It's embarrassing to recall those early discoveries and disasters. I really did some terrible things and the mechanics who serviced my machine must have thought I was sewing through fence palings, judging by the number of needles I was using. However, I was lucky to receive plenty of good advice from them about what I could and couldn't do, and the best and safest way to achieve the effects I wanted. I also learned the importance of regular maintenance, cleaning and oiling of my machine – and this is something I've been impressing on my students ever since.

In painting classes at Art school, I learned to apply broad areas of colour and gradually refine them, adding details as I progressed. Now, I make pictures in a similar way with textiles. I begin by sorting and selecting from my collection of silky fabric scraps, generally choosing close colour harmonies first and adding contrasts later. The fabrics are bonded to a very firm non-woven interfacing, then manipulated with a satay stick into interesting creases and folds as I sew. Like a painter, I work from low to high, starting with straight stitching, then adding satin stitch, couching and, finally, raised effects like machine beading and the circular bumps of zigzag which resemble barnacles. I tell my students that it's a little like learning to drive in an open paddock. The flatter and smoother the area, the more freedom there is to drive in any direction.

THE CREATIVE PROCESS

The discipline of planning a design on paper first is not one that appeals to me. I have a very low boredom threshold, so I can't bear the limitation of making plans or drawings first. I prefer to launch myself into the unknown and see what develops, and I work best when interacting directly with the fabric and the technique. This gives me a more exciting result, free from clichés, as ideas I didn't know I had seem to bubble up like ground water. Frequent pauses for assessment, with the piece pinned to the wall are essential for ongoing evaluation. Often, turning a piece upside down or sideways brings a fresh look to

a subject, which usually begins as an abstract arrangement of colours, and may evolve into something more realistic. It's exciting seeing an idea emerge and develop.

Research and Experimentation

While I rarely use formal design procedures, making samples with combinations of materials and techniques is vital. I strongly advise my students to try several different ways of interpreting an idea, then choose the one that best suits their time, materials and skill level. In this way, I reassure them that they'll be able to select the best method they thought of, not the only one that came to mind.

Playing with words is almost as much fun as playing with fabric. I recommend that my students silence critical comments from family members who may be unimpressed with a collection of experimental results by insisting that, 'It's not playtime, it's essential research into intuitive manipulation of textile surfaces!' Playing with the scraps, and fiddling with the materials is the way I overcome that first intimidating hurdle of beginning a new project. I keep telling myself that it's normal to find that the first bits don't work, but I'd better get on with it so the next bits will!

Research for me means spending valuable time bringing scraps, offcuts and precious fragments together with the sewing machine in unlikely combinations to create new ideas. Some of these are successful enough to develop further, or perhaps become a project to be included in another book or magazine article. Some of the most interesting pieces I've made have resulted from collections of offcuts I've been given or treasures I've found at Reverse Garbage, a recycling centre in Sydney. I love the challenge of making something exquisite and beautiful out of what others consider to be useless throwouts. Perhaps because the materials cost very little, I'm not inhibited by concerns about waste, and can experiment and play until I discover another new technique which gives a fabulous result. On the other hand, very expensive fabric doesn't usually encourage experimentation, as failure can be costly. Perhaps this belief dates back to childhood, as I

BERNINA, AUSTRALIA

POSEIDON'S CAVE
28 cm x 13 cm (11 in x 5 in)

remember watching my mother spread fabrics out on the floor. Mother always bought half a metre (half a yard) less fabric than the amount specified and spent an enjoyable hour or two 'wangling' the pattern to get it to fit. I was in terrible trouble when I cut a bit right out of the middle of a carefully wangled piece of fabric for my dolls. In my family, our beautifully homemade clothes often utilised old, well-worn, soft cotton sheets as interfacing or lining, as buying lining fabric was considered extravagant. Money was tight, as my father died when I was nine, so material in our house often had several encores. Furnishing offcuts reappeared as skirts, curtains became chair covers and dresses were refurbished into cushions. Leftover fabrics were carefully hoarded in a precious scrap bag, and I'm still using up bits from my mother's collection – including silks from evening gowns I wore in my twenties.

FAST LACE

Lace has long been a passion of mine, and I've tried many different techniques of lace making, including knitting, crochet, and even a six month course in bobbin-lace making. I loved the look of it, but I'm too impatient, and bobbin lace was very slow. When I discovered that I could make lace on the sewing machine, using the machine thread like a line drawn in space, I was delighted. It's fast, it's fun, and I can use all sorts of different materials such as knitting yarn, rayon embroidery threads, bits of fabric and wonderful highlights of glitzy materials.

I've made lace by stitching onto all kinds of unlikely things, plastic onion bags, the mesh that keeps leaves out of gutters, and even on the plastic rings that hold a six-pack of beer together. One of my pieces, inspired by driftwood, is a metre- (yard-) long piece of lace made from old hessian bags, bits of plastic and lots of threads, proving that lace doesn't always have to be pretty and floral. One of my proudest achievements was when The Powerhouse Museum of Applied Arts and Sciences in Sydney purchased two of my pieces as examples of a contemporary approach to lace making.

'Fast Lace' is one of my most popular embroidery classes. Here the students learn how traditional techniques can be interpreted on the machine in a fraction of the time required for handwork. A couching foot makes it easy to stitch swirling lines of yarns onto water-soluble fabric, stretched in a metal spring embroidery hoop. A toning thread attaches the yarn almost invisibly, connecting loops wherever the lines cross. It's possible to make a piece of lace much faster than in any other way by releas-

Using different colours of rayon embroidery thread in the needle and the bobbin, overlapping small circles are stitched to form a lacy mesh.

Scraps of silky and metallic fabrics are placed on top of the soluble fabric and incorporated into the lace by stitching the same circular pattern over the edge of the fabrics.

A silky, knitted rayon ribbon is couched over the lace, using a freehand machine setting, the open freehand embroidery foot and a narrow serpentine stitch with a matching rayon embroidery thread. Loops of the silky ribbon are left hanging, reminiscent of seaweed.

ing the hoop and moving it to an adjacent area of fabric, without cutting the yarn or rethreading the machine. As in crochet or knitting, lace pieces can be made to exact garment pattern shapes and joined invisibly.

Fragments of other fabric can be attached to the lace, adding a further textural dimension. I use a similar technique when making jewellery, with small pieces of silk set in a mesh or metallic cords, like 'Cleopatra's Necklace' which was featured on the cover of the Bernina International calendar in 1995. Lace made with knitting wool is another possibility, which one student was delighted to discover was much faster than knitting, which she'd never been able to master.

THE SEVENTH WAVE SCARF

Fine, delicate lace like that in 'The Seventh Wave Scarf' is made using a background fabric of a hot-water-soluble laundry bag, which is stronger and cheaper than the cold-water-soluble fabric. I started by selecting five or six toning shades in rayon embroidery thread and filling a few bobbins with each colour. I then drew the outline of the scarf on the fabric, which I stretched in a spring hoop. I set my machine for freehand embroidery and threaded a toning colour through the needle and the bobbin.

By sewing fast and moving the hoop in small overlapping circles I made a mesh of interconnecting lines. By changing the top and bobbin colours often, subtle shaded effects are possible, and the silky rayon thread makes a soft and delicate lace.

Intensive circular scribbling attaches scraps of other fabrics to the mesh and prevents fraying. All sorts of variations are possible, using sheer or metallic bits as a contrast to the more open areas. The border of 'The Seventh Wave Scarf' is highlighted with small strips of gold mesh, painted silk and organza, hand-beaded to simulate the sun glinting on water and the tiny bubbles and shells trapped in the ripples. Dyed-to-match knitted rayon ribbon adds the contrast of a stronger, thicker line couched through the border, like the seaweed stranded at high tide by the seventh wave, the one that goes furthest up the sand.

SCHEHERAZADE'S ROBE

Some of my favourite pieces have been made using a knitted rayon, tubular ribbon, which has been dyed in harmonious colours while still in a skein. When the ribbon is couched in overlapping circles on a soluble backing, it forms a silky and sensuous lace with the different colours blending to give a shaded effect. I spent ten days making Scheherazade's Robe, a full-length, long-sleeved, ribbon-lace gown. When the embroidery was completed, the whole thing looked like a very badly made shower curtain! I had a few anxious moments as it went into the washing machine to dissolve the backing. However, the result was gorgeous — a beautiful red silky robe, apparently made as one seamless piece of lace.

A new studio in the garden, a gift from my husband in 1995, is my indispensable retreat. All the essentials are here — the computer, my sewing machine, the music system, plenty of cutting and working space for me and my students, generous display boards for work in progress, a sink, lots of power points and good lighting. Sliding doors open onto a sunny, covered verandah, overlooking a little pond, inhabited by a family of frogs. Whether I'm writing or sewing, I can look out on the garden and refresh my spirit, walk outside to pull up a few weeds, or just lie on the grass and look up at the trees. Inspiration is everywhere, from my collections of seed pods, rocks, coral, and precious bits from my travels, to the garden right outside my door. It's my special cherished place.

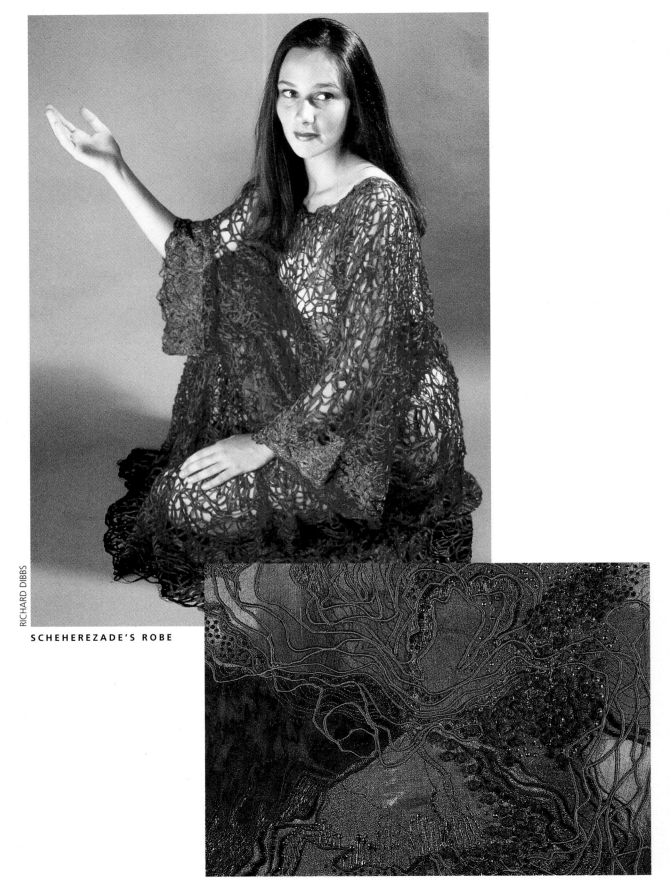

RICHARD DIBBS

SCHEHEREZADE'S ROBE

BLUE BARNACLES

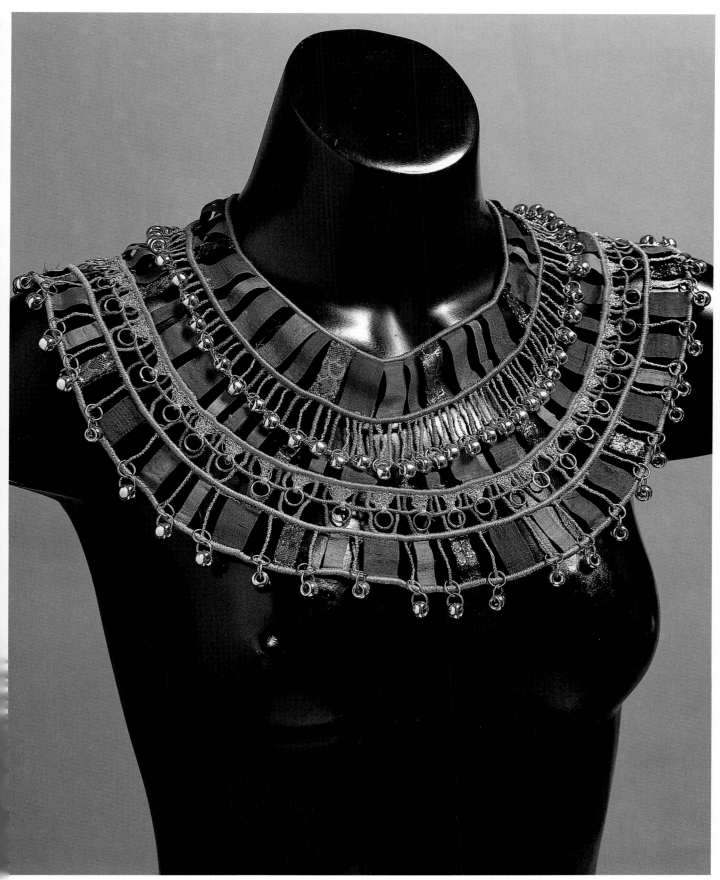

CLEOPATRA'S NECKLACE

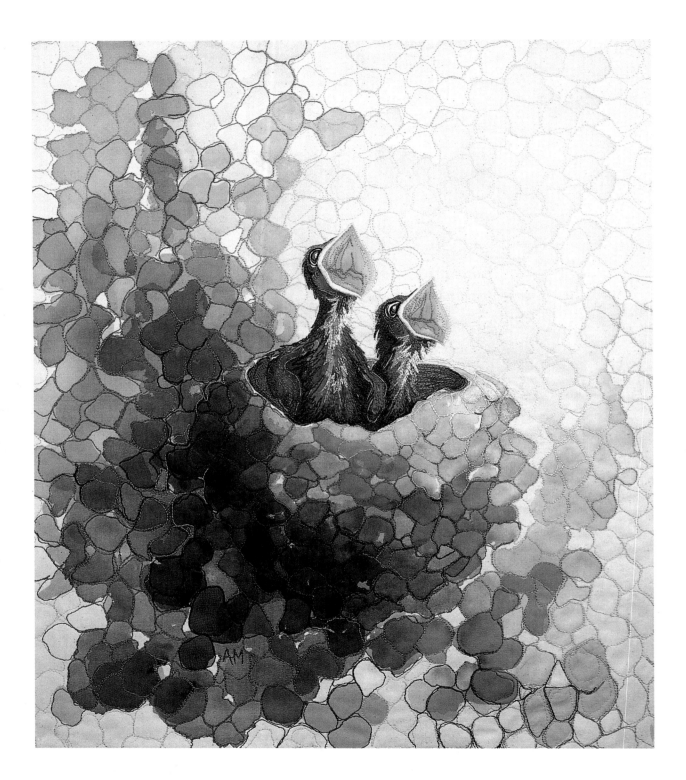

YOUNG SWALLOWS
50 cm x 61 cm (20 in x 24 in)

STITCHING LIFE

ANNEMIEKE MEIN

NEIL LORIMER

Boxes of butterflies spill a shimmering cascade over the table, reflecting the colours in a silken rainbow of scraps. Baskets of wool in glowing hues light up the shadows, and the walls are covered with exquisitely detailed drawings, thread colour samples, watercolour roughs and fabric swatches. Suspended from dry branches and twigs, delicate traceries of thread fashioned into lacy webs and egg cases revolve slowly in the warm air. Trays of insect specimens in all stages of development fill drawers and shelves. Tiny birds' nests, intricately woven into minute grey cups, cluster on a shelf beside seed pods and small bleached bones. In a gabled alcove of this beautiful studio, overlooking a sunny, old-fashioned garden, Annemieke is busy at her sewing machine, cocooned like the insects she loves, in her own special world.

From this quiet attic retreat in Sale, Victoria, have emerged textile creations that have captured the hearts of viewers around the world. Honoured with the Order of Australia Medal and represented in galleries and collections throughout the world, Annemieke describes herself as a 'wildlife artist in textiles'. Her breathtaking machine-embroidered and painted wall pieces, that seem to quiver with life, are a celebration of the deep love and respect she has for the environment, especially the beautiful area of East Gippsland where she lives.

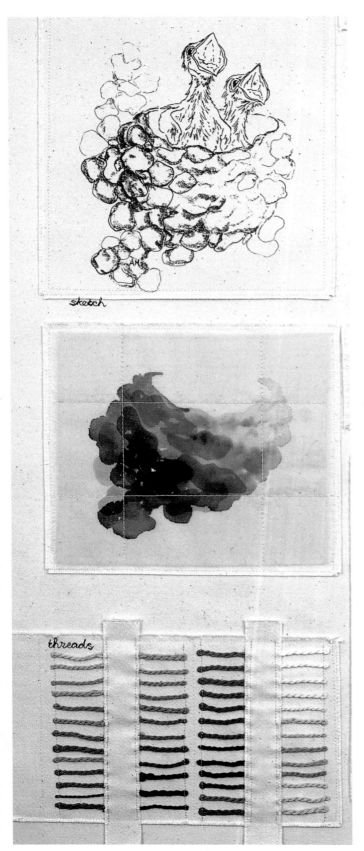

Each step of the process is thoroughly 'rehearsed' with options tried, tested, then retained or abandoned.

The worldwide success of Annemieke's work stems from a fierce determination to present her view of nature as perfectly as possible. 'Patience, practice, perseverance, experimentation, determination and presentation mixed with a little inspiration and fabric makes textile art', she maintains. This is achieved by a painstaking attention to detail at every stage of the creative process, from initial observation and drawings, to the final, beautifully presented and comprehensively chronicled records which Annemieke keeps on every piece she makes.

Although Annemieke enthusiastically embraces the time-saving advantages of modern technology, such as the computer, photocopier, camera, and electron microscope, many of her works are conceived in a tiny bush hut, built with the help of her husband, Phillip, from rocks, mud and timber collected from the surrounding landscape. 'I feel very close to nature there, without phones, electricity and running water. It's a special place for observing, listening, sketching, and learning. There are constant climatic and seasonal changes, and an abundance of flora and fauna.'

Dressmaking from the age of thirteen was the grounding for Annemieke's exquisite machine embroidery. Annemieke says that 'experimentation and trial and error, combined with a smattering of knowledge of some twenty other arts and crafts has led to the development of my work as it is today'.

YOUNG SWALLOWS
The Process
Annemieke usually begins the creative process with field studies, finding something that captures her imagination or emotions. She discovered the tiny baby swallows in a mud-daubed nest, while visiting a cave in a cliff face. Back in the studio, Annemieke began on a project that could take from six to twelve months of loving and painstaking work.

Planning and Preparation
First she collected specimens of soil, mud, rocks, feathers and an old nest, for reference.

Next she made countless sketches, cartoons, colour and tone plans before designing the full-sized

layout — a process Annemieke calls 'kitchen sinking'.

Armed with the layout, Annemieke began selecting the paints, fibres, fabrics and threads. The baby swallows, as with most of her subjects, are portrayed in larger-than-life dimension which allows the introduction of detailed textural variations and subtle colour combinations. Often, minute details, like the glitter of fish scales underwater or the subtle colours inside a bird's beak, are deliberately accentuated to capture an event, an experience, a mood or an emotion that the subject has aroused.

Painting the Design

Before the stitching began, the sheer silk fabric was painted. Annemieke set up a painting board with a full-sized sketch pinned to heavy cardboard, and covered by clear plastic and cream silk organza. All the layers were taped together to prevent them slipping or the fabric becoming distorted.

She painted the swallows onto the silk organza in three stages over two days. This ensured that the painted areas were thoroughly dry, and there was no bleeding of colour. First she painted the eyes, the beaks, and the feathers, then the nest and background areas. Annemieke worked on both the dry and wet fabric areas to create a natural mottled effect. The colours used in the nest have been diluted with water and dabbed onto the dampened background area. Only when all the rest of the painting had dried, was the inside of the nest painted.

Annemieke resists the temptation to take the silk organza off the plastic until the whole work is painted. The silk and paint create a seal onto the plastic which avoids unwanted bleeding of paint colours. The excess paint remains on the plastic once the dry silk is removed.

Choosing the Fabrics

Fabric selection begins in Annemieke's fabric storage room, where hundreds of silk and cotton fabrics in every shade imaginable are neatly folded and stacked in colour-coordinated piles, with matching threads nearby. Silk has always been Annemieke's favourite fabric to work with.

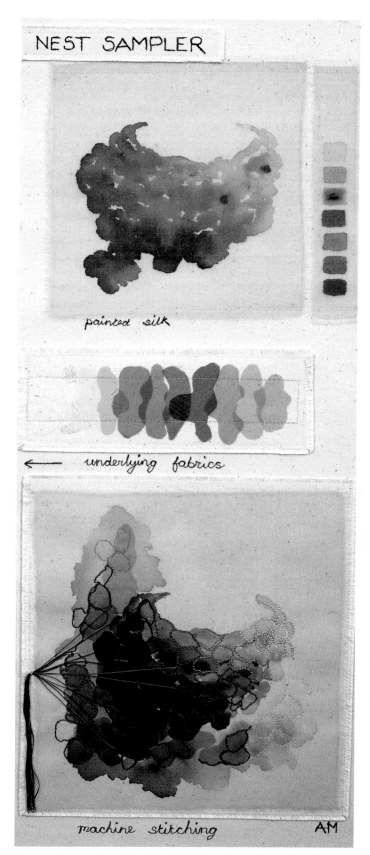

First the silk is painted and scraps of underlying fabric assessed for colour, before the stitching begins.

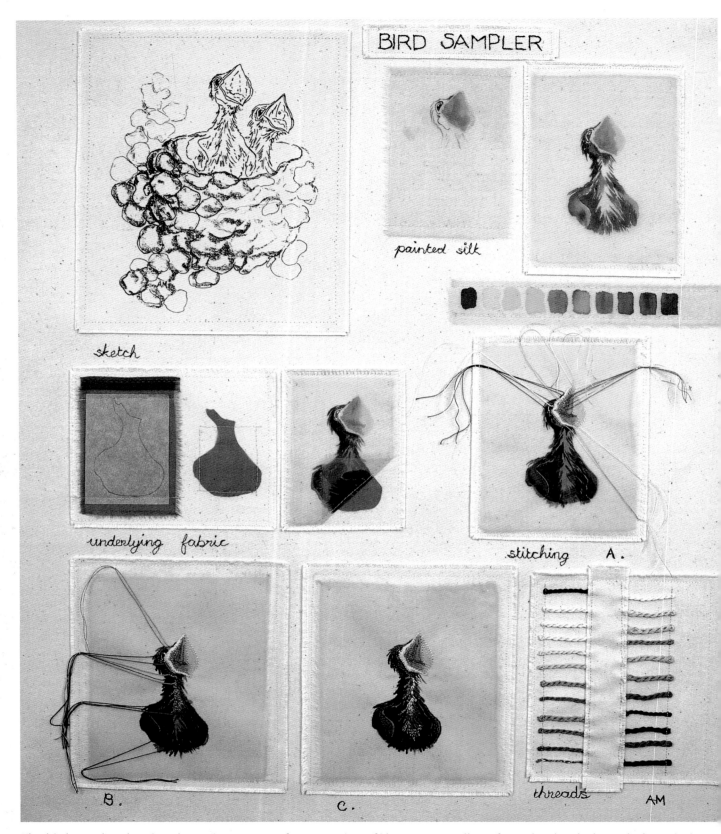

BIRD SAMPLER

painted silk

sketch

underlying fabric

stitching A.

B.

C.

threads

AM

The bird sampler, showing the various stages of construction of the young swallows from the sketch through the painting of the silk fabric, the choice of threads to the final detailed machine embroidery.

Dozens of small pieces of fabric were carefully placed with tweezers on a layer of cotton canvas underneath the painted silk, to build up the subtle richness of colour and texture required. Careful ironing with a pressing cloth over the work helped to adhere the collage, which was further stabilised with pins every five centimetres (two inches).

Machine Stitching

Machine stitching has always been a part of Annemieke's life, beginning by watching her mother, a professional designer and dressmaker of children's clothing in Haarlem, Holland. Early knitting and crochet lessons were followed by first machine lessons, on a child's Peter Pan sewing machine, which she still has. Although she now works on a Bernina 1230 computerised sewing machine, Annemieke rarely uses stitches other than straight or zigzag to achieve her precisely detailed effects.

On the swallows, she began on the eyes and beaks to get their expressions and the beak angles right, in case she has to start again. Grading the stitch width while sewing on the tiny outer beaks takes a bit of practice – Annemieke says it helps to be an octopus!

For the feathers, many different threads were used – thick and thin, matte and silky. The stitching closely followed the lines laid down in those early drawings to recreate the softness of the birds' breast feathers. Altering the stitch length by moving the fabric at different speeds while sewing enhances the feather shapes. Getting it right is of paramount importance and, in some cases, Annemieke may make a bird or insect ten or more times to achieve just the right expression or texture. Failures are ruthlessly consigned to the incinerator!

While stitching, she works with her hands spread out to stabilise the fabric, using them like an embroidery hoop. The nest was stitched by free-sewing individual shapes to simulate daubs of mud. This lesson was learned from close observation of the parent birds, who construct their nests with one beakful of mud at a time.

'This intermediate stage I often find the most difficult. The design may not yet be shaping up visually, as many jigsaw pieces are not yet in place. The studio

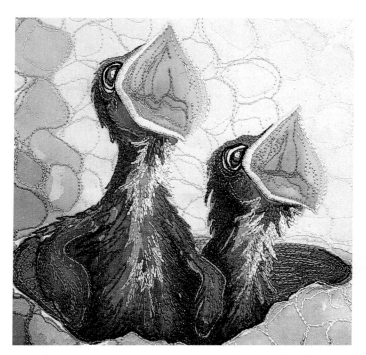

Grading the stitch width for the tiny outer beaks takes a little practice.

looks like a bomb has hit it, with fabrics, specimens, references and threads covering every available flat surface. Doubts begin to creep in. Will it ever work out? If I don't put the blinkers on, and just keep going on as planned, I'd never finish the work.'

Annemieke says that she is not a purist in her methods. She'll combine any texture or technique in a project if it will give her the desired effect. If a readymade material to suit a specific purpose is not available, she makes her own. This has led to some unusual exercises, such as miniature rug-hooking with fine silk threads to create the furry back of a moth, or heating and shrinking plastic to make the ethereal shimmering wings of a dragonfly.

Handwork

Handwork followed the machine stitching. The hundreds of thread ends were darned through to the back of the work and securely tied off. Hand embroidery was added to build up textured areas. Feature areas were padded and quilted to achieve a low-relief effect. Finally, the main parts were machine stitched to a painted cotton canvas backing.

The Result

'Knowing when to stop is a major consideration, keeping simplicity and space in the finished work,' Annemieke says. She carefully files daily work notes of time and expenses, materials used, trials and errors, and new ideas, along with photographs and transparencies of work in progress. When all is completed to her satisfaction, Annemieke organises the mounting and framing, with detailed conservation notes attached.

For Annemieke, the final difficulty is deciding the fate of a piece, and whether to present it for sale or exhibition. Having breathed life into a work, having lived with it from conception, through birth, and bringing it to glorious fulfilment, relinquishing a piece is perhaps the most painful part of all.

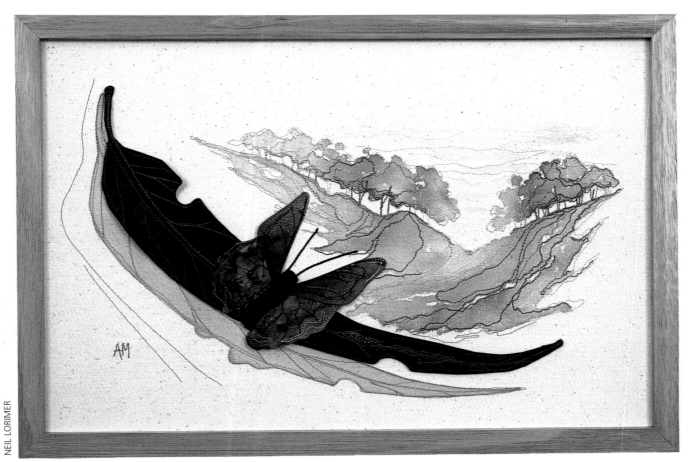

NEIL LORIMER

BUTTERFLY SUNRISE

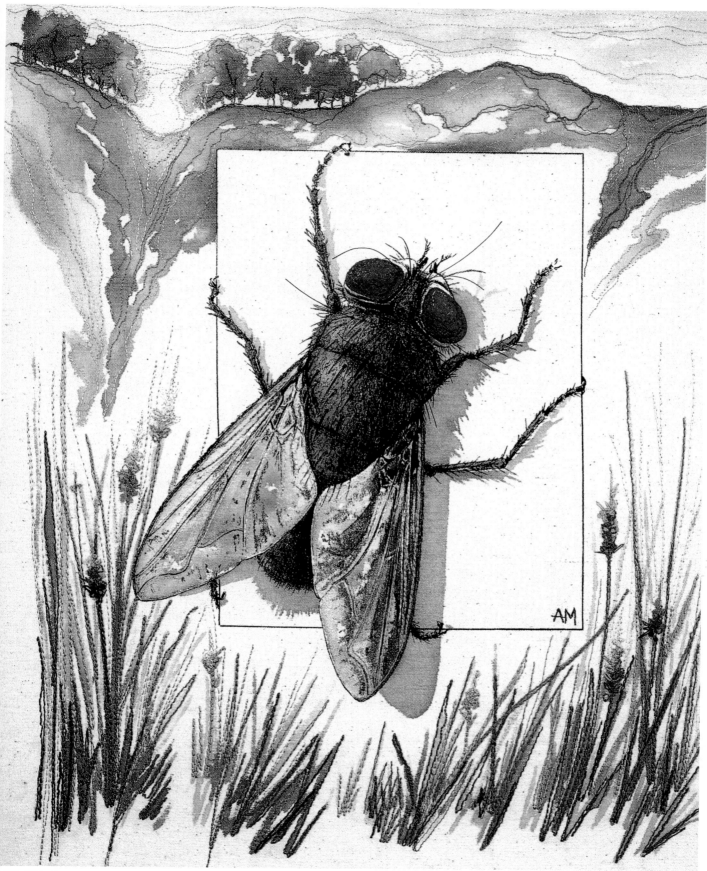

HE FERAL FLY

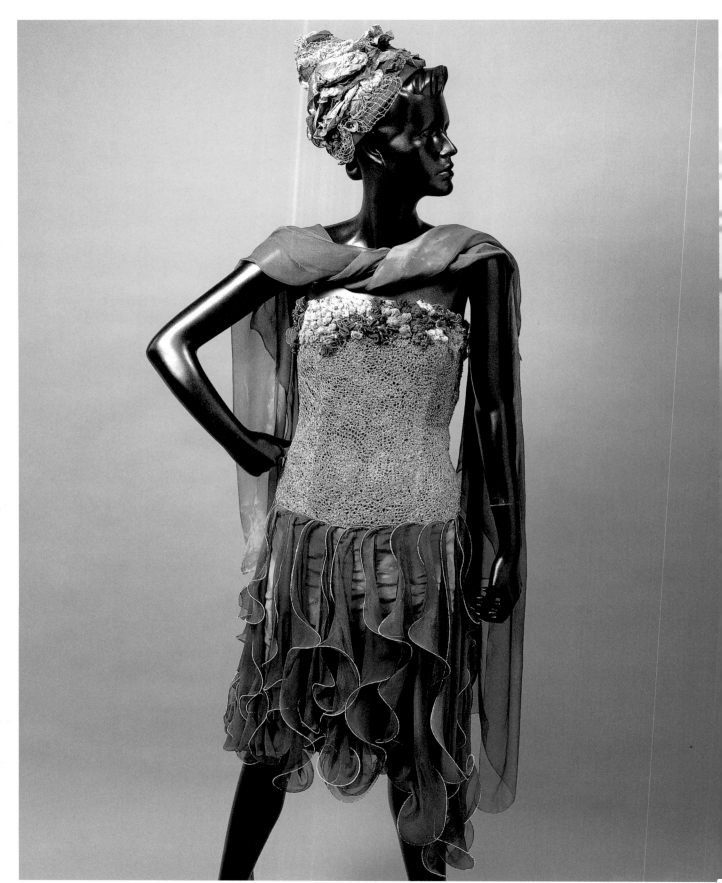

NEPTUNE'S BRIDE

FASHION AND FANTASY

WENDY WRIGHT

INSCAPE PHOTOGRAPHY

Wendy Wright's unique combinations of innovative sewing techniques, glorious colours and elegant designs have won her numerous prizes for her garments in many prestigious textile and fashion competitions. Much of her inspiration comes from fleeting glimpses of the colours and textures of the landscape she travels through to workshops around Australia and New Zealand. Wendy describes her work as somewhat surrealist, and titles such as 'Pacific Princess', 'Neptune's Bride' and 'Peacock of the Sea' speak eloquently of her love of the richness of colours in the ocean.

Making garments of exhibition and competition standard requires an enormous allocation of time, concentration and resources, and this can be difficult when there are many demands for her teaching time. 'Snatching time to meet exhibition commitments isn't easy,' Wendy says, ruefully. 'Beginning a major piece is the most difficult time, as I know it will possess every waking hour for at least three months. Making that kind of a commitment is quite daunting! I generally have a good tidy-up in the studio, clear the decks, clean the house and sweep the floors until I can't find any more excuses and I have to make a start. From then on I'm totally absorbed. Sometimes my only escape from the sewing machine and the dye pot are gardening and walking, but these relaxing pastimes give me fresh inspiration!'

NEPTUNE'S BRIDE
Detail of the bodice

Careful arrangement of the studio area at Wendy's home in Ipswich, Queensland, has created a multi-purpose room suitable for the many different techniques she loves to use. Originally a garage, the space now works well, with good ventilation and lighting. There is an area for the sewing machine and overlocker, and benches around two sides of the the room for students. A large double-sided table has been specially made for dyeing the three metres (three yards) of full-width fabric Wendy uses. For heirloom work, the table top is reversed so the clean side is uppermost. The studio space also houses an indigo vat. Wendy smiles as she recalls her first experience with indigo as she gazed into that 'shiny, slimy, evil-looking brew'. However, she was soon converted minutes later when the first pieces of silk were removed from the vat and allowed to oxidise, magically changing from copper to green, then to indigo blue. 'I became addicted instantly.' The seventy-litre (fifteen-gallon) vat is particularly tall to accommodate 'arashi shibori' a traditional dyeing technique where cloth is wrapped around a pole, tied tightly, then dyed. Because of the importance of indigo dyeing in Wendy's work, she maintains her vat carefully, often over three or four months. 'I've even had a friend "babysit" my vat for me when I was away on a teaching tour. She called in to the workshop every few days to stir and feed the vat with chemicals to keep it "alive" – rather like a ginger beer plant.'

'The whole studio area can be washed out, if I get a bit too exuberant with my dyeing processes,' says Wendy, practical as always. A green tree frog has shared the studio for the last five years, returning every spring to his favourite place behind the reels of blue rayon embroidery thread.

Net is created by stitching a grid on a double layer of soluble fabric. Once the grid lines are laid down, a narrow zigzag is stitched over them with a variety of thread colours to add highlights.

Using three threads through the needle and an interesting colour in the bobbin, interconnecting circles are stitched on a double layer of soluble fabric.

For the bodice, different-sized spiralling circles, stitched with matching thread in the needle and shirring elastic in the bobbin were stuffed with wool or cotton wool.

NEPTUNE'S BRIDE

From Inspiration to Design

'My pieces are made at least three times in my head,' Wendy explains, referring to a design process she has evolved over many years. 'Sometimes I might do a brief sketch for the difficult bits, but mainly I work out all the problems as I travel, or take my usual afternoon walk. Inspirations from reef or rainforest become images, incorporating colour and texture, and I visualise the design of the garment so I can assess the amount of fabric I'll need to paint or dye. Then I consider the texture of the finished piece and how to achieve it — machine embroidery, shibori, cutwork, lace or sculptural techniques.'

Once Wendy has sketched the garment, the process of fabric selection begins. Wendy explores a range of fabrics of different weights — often looking at several different types of silks. Next the fabrics are dyed to establish the colour theme of the garment, then the embroidery is added. Maintaining the flow and drape of the beautiful dyed silks is important, so Wendy rarely uses backing or stiffening in her work. 'I use a hoop constantly and, if necessary I can embroider seven-metre (seven-yard) lengths of full-width fabric, from which I can cut out garments.' Fantasy costumes like 'Neptune's Bride' demonstrate a total concept expressed in textile. The surging waves are interpreted in multiple panels of hand-dyed silk chiffon, the edges corded with metallic threads over nylon fishing line to create the swirling effect of movement.

Seams may be sewn before embroidery so the design can continue uninterrupted, or sewn after embroidery so the garment pieces can be embroidered and fitted more easily.

A veil of finest silk chiffon around the shoulders has the softness of a wave caressing the shore.

Fishing Line Cording

The fluid, ruffled edge which is a feature of 'Neptune's Bride' is seen in many of Wendy's creations. It is supported by varying weights of nylon fishing line or even the very heavy nylon line used in garden brush cutters. Wendy prefers this to wire as it is quite thick and remains flexible, bouncing back into shape even after packaging. This is a real bonus as many of her garments are sent to competitions, where they have won several awards.

To attach the line, Wendy uses a grooved manual buttonhole foot and a zigzag stitch with the width set at about 4 and the stitch length 0.5–1.5, depending on the thickness of the thread she is using. This stitching creates a rolled hem effect, with the nylon line secured inside the roll.

Decorating the Bodice

Over four thousand metres (yards) of thread have been used to make the lace bodice. Wendy stretched two layers of water-soluble fabric in the hoop, and used a freehand machine set-up with three or more threads through a size 100 needle with a large eye, and a toning colour in the bobbin. 'Loosen the top tension a few degrees, and stitch in interconnecting circles. It's really important to make sure that all the circles are connected,' Wendy emphasises, 'or the lace will fall apart when the backing is dissolved.'

The top of the lacy bodice is encrusted with manipulated and embroidered fabric, suggesting forms of corals and seaweed. Using a shirring elastic in the bobbin, and a colour to match the fabric

NEPTUNE'S BRIDE
Detail of the skirt hem

through the needle, Wendy stitched the hooped fabric in spiralling circles of different sizes. When the fabric was removed from the hoop, the elastic pulled it together in little puffs, which were stuffed with coloured wool or net. The creases in the shirred fabric produced wonderful shadows.

Creating the Headdress

Continuing the marine theme of 'Neptune's Bride', Wendy made the stunning headdress in the form of a cone shell. Tiny moulded silk paper shells and shirred and beaded fabrics encrust layers of moulded silk paper, overlaid with lace and net made on the sewing machine.

In contrast to the free-form circles on the bodice, the net is stitched in a regular grid over water-soluble fabric – first with a straight stitch, then with a narrow zigzag to add strength.

Wendy's daughter, Jane, often models these creations, as she did as a little girl when the beautiful dresses Wendy sewed attracted so much attention and interest. Eventually, Wendy was offered a teaching position with a major sewing machine company. 'I'd explored the sewing machine thoroughly through its normal use from an early age, creating original garments, and teaching appliqué and cutwork. A workshop with Joy Clucas, from England, in the early 1970s provided the catalyst that sent me spinning off in a new and wonderful direction. I spent every spare moment practising and experimenting.'

In search of more information, Wendy completed the Associate Diploma of Visual Arts at Kelvin Grove CAE, (now the University of Queensland), in which she majored in Textiles and Machine Embroidery.

Wendy believes that knowing your machine thoroughly is an essential step towards creativity and her students around Australia would heartily agree. Courses in basic machine sewing, progressing to more challenging techniques such as heirloom sewing, appliqué and machine embroidery are among her most popular workshops.

Colour is the element Wendy says she can't live without. 'Combinations of colour are never-ending, and each selection is a revelation and an exciting journey of discovery!'

NEPTUNE'S BRIDE
Detail of the headdress

THE FAIRY BOWL

The sculptural forms she uses in garments are now leading her off on another wonderful exploration, creating enchanting little fairy bowls, made from threads and precious scraps from earlier projects. These scraps are sandwiched between two layers of soluble fabric and freehand stitched in a pattern of small interlocking circles. This creates a lacy fabric in which all the fibres are connected. Wendy fits this fabric around a glass or plastic bowl and pins darts in the fabric until it fits exactly. Next, she cuts away the excess fabric from the darts and butts the edges up against one another, before stitching over them with more freehand embroidery which joins the pieces invisibly. When she is satisfied with the shape, Wendy dissolves the fabric, revealing the lace bowl. The application of fabric stiffener and some careful moulding are the final steps.

'Love, many good wishes and sensitivity are the ingredients which I sew into a lacy globe. Frustration is to be left outside the room, and only total enjoyment is to be taken to the machine.'

Who could resist such a wonderful prescription for serenity?

THE FAIRY BOWL
13 cm (5 in) high

THE FISH PANEL
46 cm (18 in) diameter

A PASSIONATE COMMITMENT

HELEN LANCASTER

EARDLEY LANCASTER

Helen Lancaster is emphatic, concerned and committed. Her thought-provoking artworks in textiles, watercolour and collage are dedicated to raising consciousness about the fragile and threatened beauty of nature. Every piece that Helen makes drives home a message that this is the only world we have and we need to cherish it. 'I'm passionate about many things, but especially the part man is playing in his environment, and the effect that this has on areas such as the Barrier Reef, and rare and vanishing creatures. I call myself an environmental conceptualist, and the concept is of major concern, whether I am creating clothing, hats or wall pieces. Nothing is made for its functional purpose, rather for its the-

atricality, narrative content, to excite conversation, stimulate memory, or research.'

Helen expresses her message of concern in innovative ways, creating a collection of handpainted garments decorated with patterns inspired by the plumage patterns of endangered bird species. Fabulous headpieces, intensively embroidered on plastic with delicate antennae, legs quivering and shimmering, re-create gorgeously patterned coral crabs and crustaceans. Spectacular garments, heavy with the weight of millions of machine-embroidered stitches are ornamented with carefully researched portraits of fish, or elaborately manipulated and painted fabrics. One series of wall panels 'The

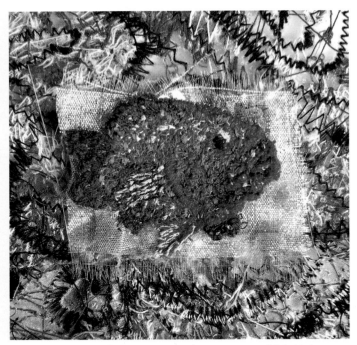

A single isolated fish swims in a barren sea, which Helen creates by stitching over acetate.

Barrier Reef Corporate Wall' is like the multiple windows in an aquarium, with kaleidoscopic glimpses of fish flashing by, enhanced by the magnifying effect of the glass. When completed, there will be one hundred and fifty individual units, each 30 cm (12 in) square.

Communicating and teaching have been part of Helen's life since beginning her career as an art teacher, then moving from secondary school teaching to tertiary lecturing in Art and Humanities, always with an enthusiasm and great love for both her subject and her students. Now, working as a freelance artist and writer, Helen is sought after as an inspirational speaker whose ability to enthuse her audience is a tribute to the painstaking research, wealth of experience and energy she brings to her subject.

The move to machine embroidery was a gradual one, via experiments with paint, then yarn and sculptural crochet, which included a 20 m (22 yd) crocheted Barrier Reef, composed of dozens of individual organisms. A Walk Along the Beach, Helen's first major exhibition in 1980, consisted of machine embroidery, created by machine couching metres (yards) of woollen threads onto a base fabric. Polystyrene chunks inserted between the fabric and the base panel created a high-relief effect. 'No-one else was working like this at the time, and very little machine embroidery in free art forms was being done. The twelve works were eventually exhibited in Vienna, along with the crocheted Barrier Reef.'

The concept of recycling is one Helen embraces with zeal. 'Reverse Garbage fascinates me,' she says, referring to her favourite materials resource, a centre in Sydney which recycles offcuts and discards for creative community use. 'I'm a vibrant, organic creature, not a hard-edged meticulous person. I collect strange bits and pieces and I seem to work best when I'm surrounded by multiple choices in fabrics, ideas and inspiration.'

The creative environment Helen calls home is shared with her husband, an artist and photographer, which means that work space is at a premium. 'Our lounge room is our work space,' Helen confesses, 'as the studio space is taken up with materials storage, unsold works and a huge reference library of books and magazines which we use all the time and couldn't live without. Both of us make a considerable mess when we work, spreading out for the process of selection and gradually eliminating choices as we finally arrive at the finished product. We have great admiration and respect for each other's artistic achievements, and we're tolerant and encouraging, despite what may sometimes become an "over-the-top" situation with photographs drying, paintings perched for viewing, or materials and bagged fabrics vying for visual attention.'

THE FISH PANEL
The Concept Translated

'Where Have All The Fish Gone' is a series of machine-embroidered panels in which Helen questions the future of our planet. In the 'Fish' panel, fragmented pieces of plastic are embroidered in dark and muted colours, representing a barren ocean in which a single fish is isolated, under the disembodied head of a fish god, the father of all.

Clear acetate sheet is one of Helen's favourite materials and is readily found at Reverse Garbage. 'Working on plastic is fun as it feeds through the machine easily and is firm enough to sew without a stabiliser.'

Helen prefers to use supersheen or polycotton threads, contrasting the matte threads with the shiny background – a technique which is especially effective with Barrier Reef themes.

Dots, Dots and More Dots!

Dots, large and small, are Helen's current passion. 'I love them sprinkled tantalisingly through a work, in patches, surrounded by linear highlights. Raised dots, lowered dots, just dots! They're time-consuming, drive-me-mad creatures which occur in many of my watercolours and my embroidery.'

On the fish bodies, hundreds of little dots are stitched on a firm surface of red satin, layered under plastic. To accomplish this, Helen uses a freehand setting on a wide zigzag and sews several stitches in the same place, then moves position after each group of stitches. To create the dots, place the red satin cloth under the acetate, set the stitch width to 5 and the stitch length to near 0. Stitch the dots in a rhythmic way, alternating the lifting of the presser foot with the pressure on the foot pedal. This creates raised bumps, linked by a connecting thread which is later trimmed off. Different shades of blue have been used on the red background to give a gradation of colour across the area.

To intensify the colour, Helen outlines each dot with black straight stitches which also link the dots.

Then, she sets a stitch width of 2½ and a stitch length of 0 and fills in some areas of the background with freehand stitching. This stitching textures the background and covers the black connecting stitches. The thread colours are varied to reflect the changing colours of the fish scales from red to gold. Small areas of the plastic have been left unstitched to reflect and shine as if in water.

Twin-needle Work

Helen uses a twin needle for many of the textured effects she includes in her work, intrigued and excited by the surface and colour changes that occur in intensively-stitched fabric. To form the fish fins, close rows of stitching with a twin needle on red satin gather the fabric together, forming a firm, ridged surface. To achieve this, the stitch width is set to 2½ and the stitch length to 1½. Thread colours vary to highlight the shape which is further embroidered with the same coloured dots as she used on the fish body. The edge is outlined with satin stitch.

The Background

The negative and positive spaces become another area of choice, because by underlaying material or embroidering directly on the plastic, transparency and translucency become important. Light is an essential element.

Dots are an outstanding feature of Helen's work, creating texture and defining the image. She varies the thread colour for added interest.

Once the dots are stitched and the connecting threads cut, the dots are outlined in black straight stitches. Finally, most of the area between the dots is covered with zigzag stitching in gold and red.

The fish fins are created with very close zigzag stitching on red satin. The highly textured fabric is then embroidered with bright dots and the edges with satin stitch.

Stitching freely with zigzag stitches in varying widths and directions, Helen creates linear rhythms and texture that is full of movement. Most of the thread ends are left hanging to add to the fibrous surface.

THE ICE PANEL

The 'Ice' panel combines a view of the world seen from space with an impression of cold Antarctic waters, the last untamed wilderness where whales and other sea creatures are under threat. Crystal organza, another of Helen's favourite fabrics, has been pieced and intensively stitched, then manipulated into deep folds, to create a surface reminiscent of the antarctic landscape or a wild ocean.

Intensive high-speed sewing textures and changes the surface of the fabric, an effect which is further enhanced by the fact that Helen does not use a hoop. Beginning with a layer of crystal organza and lamé, Helen has distorted, layered and sandwiched the fabrics in many different directions. Next, she ran zigzag stitching backwards and forwards, manipulating the fabric into peaks and troughs. Fragments of fabric were added at random, and Helen stops frequently to assess the result, before adding or subtracting more pieces to achieve the effect. She works intuitively, spurred by a mental picture of what she is trying to achieve.

'This technique looks abominable up close, but distance and light combine to make it magical.'

There is no additional padding or support under this panel or 'The Fish Panel'. The high-relief effect was achieved solely by the stitching. When the stitching was completed, the finished panels were mounted on a circular base which was attached to a square of translucent perspex.

Eventually, Helen hopes to complete twelve panels in this series.

'Time is my worst enemy,' Helen laments. 'At present, I have so many ideas jiggling in my head for priority that sometimes I just have to cut myself off from the stimulation of reading, music and poetry. I now realise that even if I worked twenty-four hours a day for the rest of my life, I'd still never be able to achieve everything I wanted to. I don't make samples. Learning the hard way, I've found that sketching in detail destroys the fluidity of my creation and the translation into paint or stitchery – too much energy is expended. For me, intuition is the only way to go. The creative rush of joy is something that has to be experienced.'

The ocean is represented with circles and wavy lines of zigzag stitching on acetate. Stitches are stretched, woven, thick and thin – all contributing to the fabulous texture.

Crystal organza and lamé are sandwiched and layered, then manipulated with zigzag stitching to create relief and texture.

THE ICE PANEL
46 cm (18 in) diameter

EARDLEY LANCASTER

BLUE SWIMMER CRAB HAT

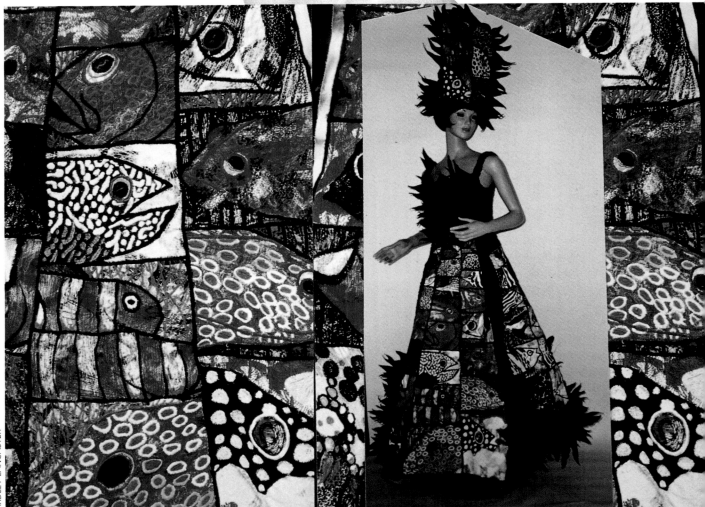

EARDLEY LANCASTER

PRINCESS OF THE REEF

ERMIT CRAB HAT

LUXOR WALLHANGING
33 cm x 17 cm (13 in x 6³/4 in)

A COLLECTION OF BRIGHT JEWELS

JUDITH PINNELL

Age is no barrier to being creative,' declares Judith Pinnell firmly. 'I've discovered that there is life after motherhood and grandmotherhood. There's ME! Starting late has its drawbacks, but imagine how it would be if one had never started at all.'

Looking at Judith's vividly exotic silk paper creations, it's hard to believe that she has been working in this wonderfully expressive textile medium for only four years.

Although Australian born, Judith spent twenty-nine years living in England, where her daughters were born and educated. A determined woman can accomplish much. Completing the City and Guilds certificate in Needlework and Design

from the Embroiderers Guild in England took four years of what Judith describes as 'really hard slog, running a home, coping with teenage daughters on the rampage, and a husband who was absent on business many weeks of the year'. Despite health problems and family dramas, Judith was thrilled to achieve an excellent result, but found that the stress had taken its toll and the next year she did what this busy lady describes as 'nothing', before a textile dyeing and decorating course set her well on the way to what she says is a 'dreaded affliction, creative madness'. A two-day workshop with English machine embroiderer, Joy Clucas in 1983 was a final turning point. Suddenly,

the hand-embroidery she had so enjoyed seemed tedious. 'I was really hooked,' Judith recalls, 'or was it, all stitched up?'

In 1983, her English husband decided to retire to Perth, Western Australia. Busy as always, Judith joined a machine-embroidery group that was being formed, and soon after found herself their tutor. 'This really stretched my capabilities, and the skills I had gathered during the years of study were put to practical use. Teaching other people really forced me to learn new techniques and ways of creating.'

In the early days, Judith laboriously drew up every detail of a project, and followed the plan to the end. Now, she's much more confident in her approach. 'I think about the piece from start to finish, going through my fabrics, choosing my colours, threads, cords and wools. Then I lay everything together and begin to add and subtract from the collection. This can take days, so I keep several pieces in the studio where I can see them.'

SILK PAPER

Silk paper is a lustrous and textured fabric somewhere between felt and paper, which has many more uses than conventional paper because of its strength. Judith makes her own silk paper, then cuts and stitches it to create gorgeous bags, purses, costume jewellery and masks. She calls it 'the most innovative substrate to become available to the textile artist this decade'. Since incorporating silk paper into her work, Judith has been invited to tutor at various regional residential courses around Australia, selected for prestigious exhibitions, and was delighted to be included in the 1995 *Fibrearts Design Book* in the United States.

Making Silk Paper

To make the silk paper, Judith pulls lengths of fibre from the silk tops, and spreads them in overlapping rows over a layer of net placed on a large sheet of plastic. She spreads out a second and third layer of silk, each layer at right angles to the layer below, so that the net is completely covered. To maintain the

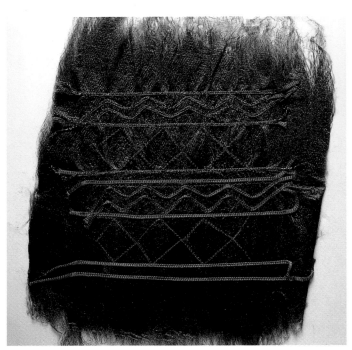

Couching is a feature of many of Judith's pieces, including 'Fragments From the Pharaohs' and 'Venezia'. Applying a second couched cord over the top of the first adds a further dimension.

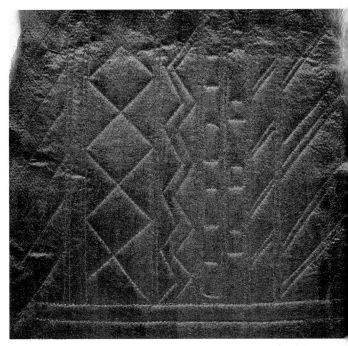

Simple geometric quilting has great impact worked in metallic threads on silk paper.

VENEZIA MASK

lustre of the silk, the fibres in each layer should be kept orderly and parallel. She then covers the silk with a second piece of net, which she paints with a solution of one teaspoon of dishwashing detergent to five cups of water, applied with a 5 cm (2 in) paint-brush. 'It's important to have the silk completely wet through', Judith advises 'so turn the silk over and wet the other side thoroughly as well. Don't worry if you seem to have an excess of soap suds. Just mop them up and keep going.'

To make the fibres adhere together in a sheet, she now paints both sides of the wet silk with a liquid textile medium, which is allowed to dry. Judith dries her silk paper on specially constructed frames covered with plastic mesh but, for beginners, she says that cake racks work very well for smaller pieces. The silk paper should be dried completely before the net is removed. Finally, she presses the silk paper under a pressing cloth. Judith takes larger sheets of silk paper to a friendly local dry cleaner for pressing.

Using Silk Paper

Silk paper offers wonderful possibilities for sculptural works, as seen in Judith's mask, 'Venezia', which was embellished with couching, metallic threads, fine net, metallic gauze and sequin waste, before it was wet with water to soften the paper. She applied more textile medium to both sides and moulded the mask over a three-dimensional mask form, then left it to dry.

For moulded projects, Judith uses a heavier acrylic gloss medium, diluted 50/50 with water. 'If I'm working on a three-dimensional project, I begin by constructing the article in butcher's paper, pinning the pieces together or using masking tape to join them. This is a good exercise when making articles in various sizes, like purses, boxes and bags. Once the shape and size are established, I select a base colour and choose complementary fabrics and threads. I usually make a small sample, using the exact fabrics, threads and thicknesses of silk paper that will be used for the main piece. I've learned the hard way that it's important to do a test run first.

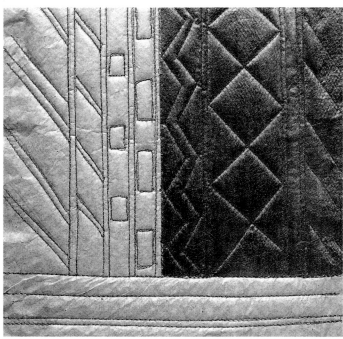

The quilting is stitched over tissue paper which is later torn away. Using an interesting thread in both the needle and the bobbin allows the work to be viewed from both sides.

Reverse appliqué is used to create Judith's sparkling windows, so reminiscent of shisha work. Squares of fabric are applied to the back of the piece, stitched diagonally with two close rows of stitching, then revealed through diagonal cuts in the upper fabric.

FRAGMENTS FROM THE PHARAOHS

Judith's samplers, of which this is a beautiful example, are exquisite little jewels, reflecting her love of Indian textiles. Silk paper is sparingly quilted in a variety of sparkling threads, then couched with lustrous cords. The tiny mirrors stitched into Indian shisha work are simulated with scraps of metallic fabrics which are set into cut and folded windows.

Judith draws her inspiration for her current work from several sources. 'Since first visiting India (my husband's birthplace) in 1990, I have been drawing inspiration from the vivid colours and designs I saw there. I find it a very free and easy style to interpret, with tassels galore and imitation shisha work which is easy to do on the machine.

The early Byzantine and Egyptian eras were also bursting with riches, both in decoration and design, and are full of inspiration for embroiderers.

Lighted Windows

First, Judith draws the outline of the window and stitches it onto the background fabric. Next, she

Judith cuts through the top layers of fabric to reveal the bright metallic fabric beneath.

bastes together two or three squares of different-coloured appliqué fabrics, looking particularly for colour and lustre which will be so effective when it peeps through the window. These layered squares are pinned or basted in place on the back of the work, over the stitched outline. On the front, she works two or three rows of stitching following the original outline and attaching the appliquéd squares at the same time.

Next, two rows of diagonal stitches about 2 mm (a scant 1/8 in) apart are worked inside the square to divide it into quarters. Judith carefully cuts inside the inner of these two lines so the points of the little triangular shapes can be folded back, revealing the layers of fabric underneath.

For a totally sumptuous effect, the narrow channels between the cut-out shapes can be couched, stitched with a decorative pattern or hand-beaded.

LUXOR WALL PANEL

Quilting is another technique Judith loves, as the padded surface of the silk paper catches the light so beautifully. It is a feature of 'Luxor', a wall panel made from brilliantly coloured silk paper, bronze lamé and metallic threads, inspired by the richness of a goldwork ornament from Tutankhamen's tomb.

Judith placed a layer of bronze lamé on top of a layer of Pellon, then sandwiched them both between two thin layers of silk paper. She drew the quilting design on tracing paper and pinned it to the front of the work, before stitching over the tracing paper, using a slightly longer-than-normal straight stitch. The tracing paper is torn away, using tweezers to remove any stubborn small fragments.

Areas enclosed by the gold quilting were cut away very close to the stitching to reveal the brilliant bronze lamé beneath.

The feathery edges of the silk paper became an integral part of the finished piece. Sparkling jewels were sewn on by hand in homage to the Pharaoh's jewelled collar and more jewels are concealed beneath the top flap.

Judith confesses that she finds the most difficult part of a project is deciding on the surface decoration. 'It's easy to overdo the decorative part – the

silk paper is so very rich and lustrous in its own right, that I have to be careful not to spoil the beauty of my background fabric. Wondering if I've put enough, or perhaps too much decoration, can be quite a dilemma. I would like to think of the pieces I make — boxes, collars, bags, masks and accessories — as a collection of bright jewels. Each piece is painstakingly and lovingly made, and I think that there is something of myself in each one.'

The love of small, brilliant and exquisite creations seems to run in the family. Judith's young grand-daughters adore spending time in Judith's studio, heading straight for their special boxes of fabric scraps (the brighter the better), felt pens, glue and glitter.

The truth of one of Judith's favourite maxims is obvious. 'Enjoy whatever project you have in hand, and remember, the more you do, the more creativity seems to come to you!'

The combination of quilting with metallic threads and reverse appliqué enhances the lustrous surface of the silk paper.

FRAGMENTS FROM THE PHAROAHS
38 cm x 41 cm (15 in x 16 in)

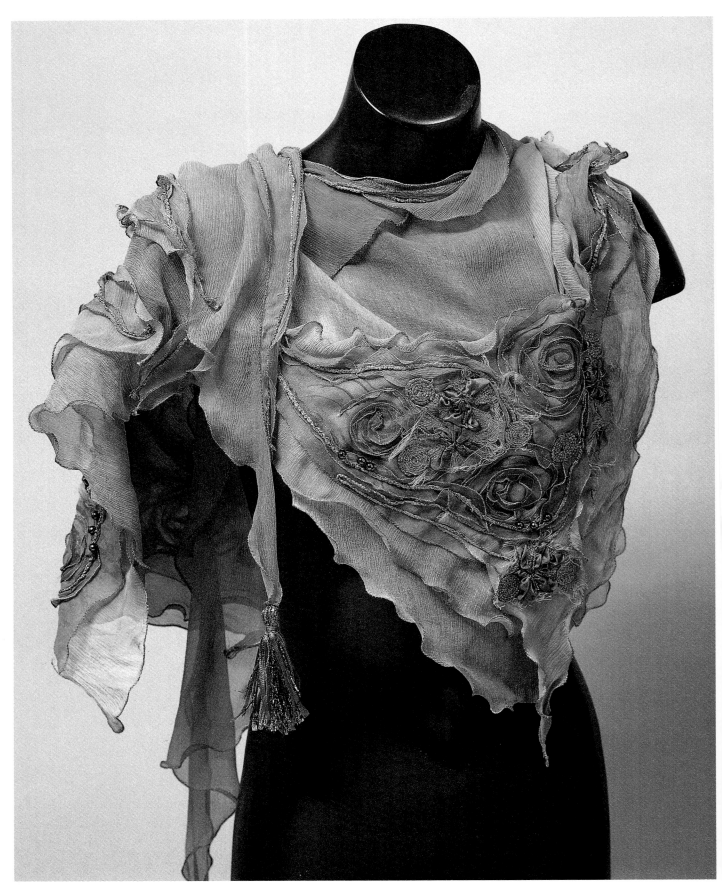

GEORGETTE WRAP

FREEFORM SCULPTURAL FASHION

TRUDY BILLINGSLEY

MICHAEL CHETHAM

Art To Wear, clothing where art meets fashion, has been a passion of Trudy Billingsley's for several years. Her most recent works have been in the area of creative clothing. For the last five years, she has been the organiser and one of the exhibitors in Art To Wear, a prestigious annual event in Sydney, featuring innovative and imaginative garments from a selected group of Australian textile artists. Trudy now creates her own patterns for many of the freeform, sculptural and very wearable garments she designs, and the legacy of professional dress-making from both her mother and grandmother has laid a firm basis of technique to which she has added her own style.

Her first forays into dressmaking were not so stylish. Trudy's father worked as a lighthouse keeper on the south coast of New South Wales, and at the tiny one-teacher primary school Trudy attended, cross-stitched placemats and voluminous bloomers were considered the correct training models for young girls learning sewing. Trudy's preference was for making kites complete with colourful fabric tails, and fabulous dolls clothes embellished with trims, buttons and braids from her mother's and grand-mother's workroom.

Living and working overseas for several years while in her twenties gave Trudy the chance to become heavily involved with traditional patchwork.

'On returning to Australia, I started to incorporate texture and surface collage into my quilts, using my first Bernina. By experimenting with various stitch programmes, I found that I could decorate my surface with three-dimensional finishes.' Many of the quilts made during this period combine landscape piecing with further embellishment, often expressing a message of concern for the environment. Although Trudy now creates mainly garments and accessories, the inspiration and love of the Australian landscape is still reflected in colours and textures.

'My studio is my favourite space,' says Trudy, 'and I'm usually at work there by 8.30 or 9 a.m. on most days.' This sunny room has a dedicated place for everything. Open shelving fills one whole wall so colour-grouped fabrics can be reached easily. Another wall is completely covered with postcards, pictures, fabric swatches, sketches, snatches of poetry, photographs, yarn samples, found objects and anything else that Trudy's keen eye has spotted, and she has 'filed' on the wall for future inspiration. The collection is continually evolving, as newer ideas form or older ones are used. Neatly stacked threads surround the sewing machine and overlocker. The carpet is as much a creative space as the table and is frequently covered with fabrics, as Trudy's ideas of colour and texture are grouped, rearranged, changed and developed until the design takes final shape. Racks of fabulous garments are stored ready for the next exhibition or sale, and baskets of tiny handbags, corsages, and balls of gorgeous couching yarns cluster around the edges. No wonder Trudy loves to spend most of her time here!

A busy teaching schedule often keeps Trudy away from her studio, as both quilters and machine-embroidery students are eager to share her passion for textiles and decorated surfaces. However, Trudy realises the importance of regular input to maintain freshness in her own work. 'Attending workshops and seminars on a variety of visual and performing arts, as well as concerts, operas, plays and films stimulate my ideas and expand my horizons. I find that regular experience of excellence in other art forms helps me avoid "creative cramp".'

Theatre and the opera also give Trudy plenty of opportunity to wear her own creations, which she does with panache. The current collection features floating layers of silky soft and sheer fabrics in subtle tertiary colours, muddy pinks and browns, dull purples, and a range of warm earthy tones, which combine beautifully with the occasional flash of copper, gold or bronze, in surface embroidery or the twisted and coiled cords which have become her trademark. Wraps are a favourite of Trudy's — some inspired by the ochre and sienna colours she observed during a recent teaching tour to Central Australia. The uneven layers of fabric are reminiscent of the ancient rock formations in the desert, with linear patterns added with embroidery and manipulated textures.

GEORGETTE WRAP

'I love to work with multiple layers of fabric, so that they float and move when worn, adding softness and femininity. I've created this wrap from layers of a hand-dyed crinkled silk georgette. Extra layers of fabric are edged with metallic yarns and cords. Because each layer is a slightly different shape and a little smaller than the one beneath, this creates an interesting arrangement of edges reminiscent of rock strata or paper bark. Sometimes the corded edges are combined with nylon fishing line so they flute and ruffle and the garment drapes gracefully when worn.'

The corded edges can be made on the machine or on the overlocker. Use a machine couching foot to attach the cord or sew fishing line along the edge of the fabric. Select zigzag stitching that is wide enough to cover both the cord and the edge of the fabric. For fishing line, a stitch length of about 1 will cover the nylon line fairly closely.

Another way to cord the edge is to roll hem the fabric first, then apply the nylon line. On the overlocker, a contrasting yarn can be threaded through the looper for the roll hemming or fed through under the foot to be couched in place.

Spirals

Trudy uses lots of small spirals to add surface interest. In fact, the spiral motif is a trademark of Trudy's

and here she has used it in two different ways:

The larger spirals are made from 2 cm (³/4 in) wide bias strips of fabric which she stitches along the edge with a narrow zigzag, then attaches in a loose spiral shape with straight stitching. By varying the width of the strip, high- and low-relief spirals create a textured effect.

The small spirals are made from lengths of cord which are created by stitching several different yarns together. Trudy begins by selecting three or four yarns, mixing a smooth yarn, a silky yarn and a plush yarn. For a flat coil, use an open-toed satin stitch foot which allows the yarns to move smoothly under the foot. Holding the yarns firmly behind and in front of the foot, stitch them together with a three-step zigzag or serpentine stitch wide enough to cover the yarns. Use matching or contrasting thread, depending on the effect you are looking for. For rounded coils, the yarns can be fed through a couching foot with a large hole or groove and stitched with a long, wide zigzag stitch.

Ribbon floss, wool, mohair, and metallic cords all combine well, and the finished cord can be coiled into a tight spiral and stitched in place with spokes of straight stitch. By varying the yarns used in the cords, Trudy can achieve very subtle colour changes. Hanging cords and tassels also feature on many of Trudy's pieces, often combined with beads.

Twisted Cords

Twisted cords appear in many of Trudy's pieces – as straps for evening bags, coiled into spirals, couched onto hems and edges or swinging freely from a yoke.

Cut lengths of several different yarns, approximately two-and-a-half times the desired finished length of the cord. Lay the lengths of yarn side by side and knot them together at each end. Hook one end over a doorknob or ask a friend to hold it for you. Hold the strands firmly stretched and place a pencil through the yarns at the other end to act as a handle. Twist the strands until they kink a little if the tension is relaxed. Keeping the cord stretched, bring the two ends together. While holding the two knotted ends, allow the cord to twist on itself. A small weight hooked over the folded end will help the cord to twist evenly. Knot the ends together and trim the strands.

Fabulous Flowers

The circular Suffolk Puff, so popular with patchworkers, is the basis for an interesting variation which Trudy has developed to create the freeform flowers which nestle among the coils and spirals.

Gather a 15 cm (6 in) circle of soft fabric around the edge, then pull it up into a round puff. Stitch it to the background with a freehand straight stitch, flattening some of the fabric to create the effect of a ruffled flower.

This fabric spiral is created from a 2 cm (³/4 in) wide bias strip which has been eased and stitched into a spiral shape.

A flower begins with a traditional Suffolk puff, which is stitched onto the background fabric with free machine embroidery worked into the folds.

A fabulous multi-coloured, textured cord can be made by twisting several cords together as they pass through the presser foot and stitching with a zigzag setting width 2, length 2¹/2.

The edges of the bias strip are stitched with a contrasting thread.

Dyed muslin fragments and hand-beading complete the ruffled flowers.

Dyed-to-match fringed scraps of a loosely woven muslin – one of Trudy's favourite fabrics – are often used under the flowers to add extra textural interest. The play of light on matte and shiny surfaces and the tiny glass beads hand-stitched in place make an intricate surface which invites further inspection.

EVENING BAGS

Small evening bags are among Trudy's most sought after items at exhibitions and sales. The fabrics she uses, such as velvets, brocades, printed silks and dyed georgettes, combined with extravagant braids, trims, tassels and cords have a handsome baroque richness which is timeless.

GOLD TABARD

Medieval costume has been the inspiration for many of Trudy's more exotic garments, such as this coat with its suggestion of medieval armour. Dozens of small squares of metallic lamé and organza are sewn into padded pillow shapes and joined in rows with cords and beads to form an open tabard. The columns of padded sections with the appearance of armour are attached only at the yoke, along with an under-layer of metallic georgette and long triangular

floating panels of crinkled metallic organza. There are also references to medieval armour and costume in the extended shoulders and double raised collar of padded and quilted lamé. Small coiled, black and gold spirals of braid embellish the yoke.

Trudy travels often, and never without a sketch-book 'as you never know when design inspiration may come'.

'What I do gives me great pleasure and fulfilment,' says Trudy, 'enriching every day of my life.'

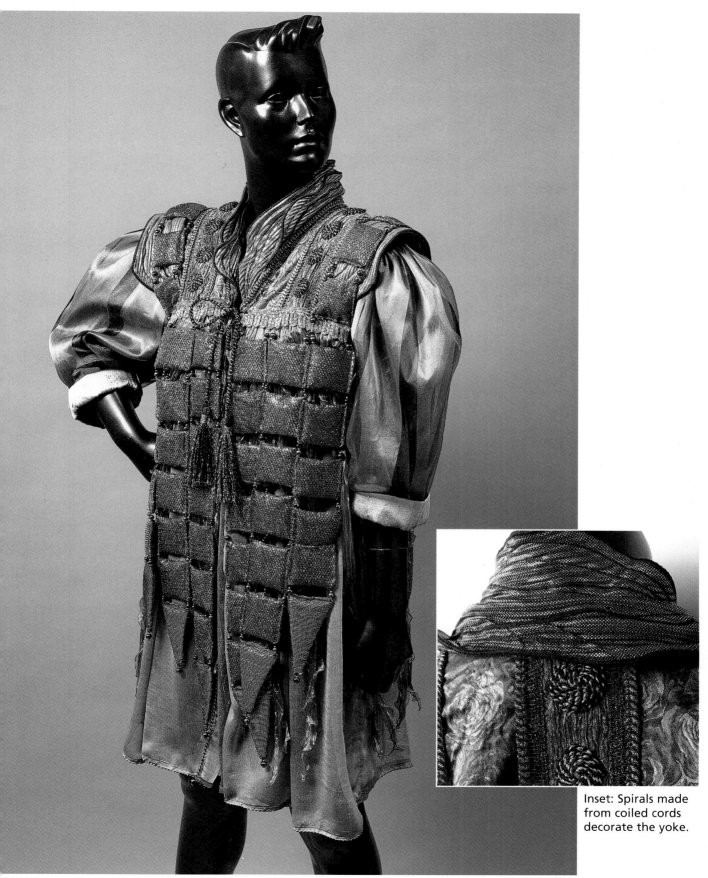

Inset: Spirals made from coiled cords decorate the yoke.

GOLD TABARD

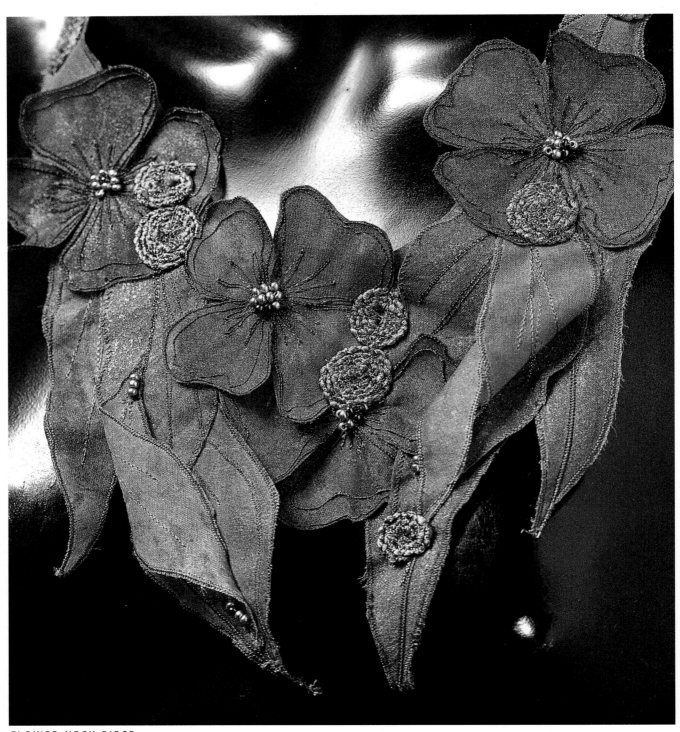

FLOWER NECK PIECE

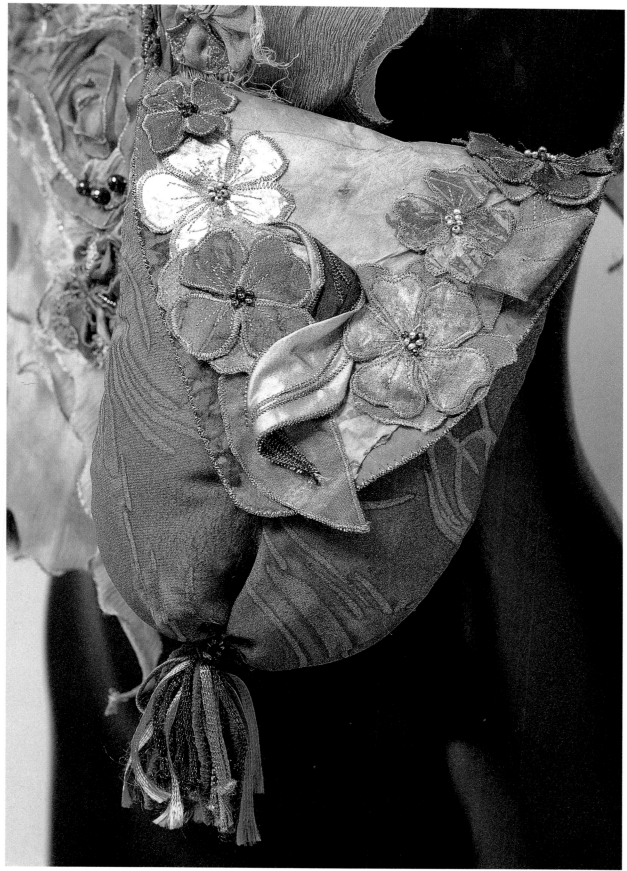

EVENING BAG

TURKISH PLUNDER CUSHION
41 cm (16 in) square

BRILLIANT BORDERS

GABRIELLA VERSTRAETEN

GENE VERSTRAETEN

When Gabriella was a schoolgirl, her homework was the most eye-catching in the class. Science projects, Maths assignments, History and English essays were decorated with intricate and kaleidoscopic borders drawn with felt pens. 'I thought it was perhaps a bit inappropriate having a decorated Maths assignment, but I did it anyway,' she laughs. The richly coloured artworks and accessories Gabriella now produces echo those early attempts, with formal borders and designs still being a favourite theme.

Playing with colours has been a passion since childhood. The little shop attached to Gabriella's studio in the Meat Market Craft Centre in Melbourne is like a sultan's treasure chest, with rich and lustrous fabrics and patterns, patterns and still more patterns, covering everything in sight. The decorated assignments are still tucked away in the attic, and the felt pens have given way to the sewing machine, which she sees as 'an extension of my arm, so drawing with the machine comes as naturally to me now as drawing with pens or pencils'.

Although the patterns Gabriella stitches are formal designs, often with symmetrical or repeated images, there's a quirky sense of humour at work here, with shapes and lines that aren't ever too exact, as if they shouldn't be taken too seriously. Even the titles of some of her works, such as 'Lucy's Trick' or 'Noughts and Crosses' hint at a tongue-in-cheek approach.

Growing up in a family where both parents were creative provided a fertile environment for a budding textile artist. Gabriella's father was a lecturer in photography and her mother, with whom Gabriella shares studio space, is a sculptor and jeweller. 'Even before I could read, I loved just looking at the pictures in my parents' art books,' she recalls. 'With my Dutch heritage, I grew up in a very decoratively rich domestic environment and I loved it. My mother and my grandmother adored sewing gorgeous little dresses for me and my sister, and going to the button shop to choose matching hair ribbons was a very special treat. I learned to sew quite early, when I was given a little sewing machine for my twelfth birthday. I knew I wanted to be an artist when I grew up, and although Mum hoped I'd follow in her footsteps with metal sculpture, it just didn't feel right.'

The love affair with textiles really began in Gabriella's final year of studying for a Bachelor of Education in Art and Craft, majoring in Textiles. One afternoon was spent working on Machine Embroidery, followed shortly afterwards by two weeks studio experience working with Annemieke Mein. At last, Gabriella had found the perfect marriage of sewing and textiles. She studied several different fibre techniques during the course, and she has since taught many of them, while working as an Art teacher, but she has always returned to machine embroidery, and now works exclusively in this field. 'I can't seem to do anything in just a small way, so I'm almost scared to explore other art forms now, in case it consumes me and I can't stop!,' she says ruefully.

Although Gabriella would love to have more time to pursue her embroidered artwork, the popularity of her sale and commission items means a heavy workload. As her machine-embroidery workshops are also in demand, a disciplined approach to production is essential.

Silks, satins and lustrous materials are Gabriella's usual fabric choices, reflecting the influence of artists such as Klimt and Hundterwasser. Repeat motifs seen in tile shops, or ethnic ornament and folk textiles, as well as many books on jewellery and buttons provide inspiration for the borders and sym-

metrical patterns which appear in so many of Gabriella's works. Seasonal colours play a big part, so that sale items will coordinate with current fashion trends. Never a slave to fashion, however, the colours Gabriella uses have her own special touch, resulting in some surprising combinations.

When creating some of her very elaborate pieces, several layers of sheer and metallic fabrics may be cut and arranged to form an iridescent surface for the embroidery. Sometimes, recycled scraps or even foil lolly papers have been used to achieve just the right touch of texture and shine.

TURKISH PLUNDER CUSHION
Design and Preparation
Gabriella begins a new commission, such as this cushion, by examining all the design possibilities: theme, colour, size, customer preference and so on. When the design issues are clarified, she prepares a detailed pencil sketch.

Choosing the Materials
Once the design plan is in place, Gabriella plays with

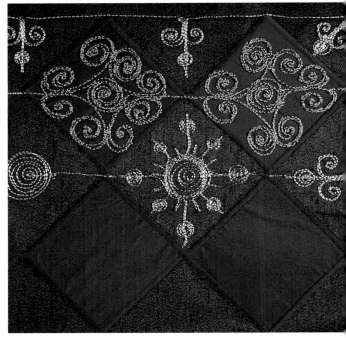

The cabling is worked in continuous spiralling patterns, using the rust-coloured silk squares as a framework.

colours and fabrics, before selecting four or five. On a cushion like 'Turkish Plunder', with its strong Middle Eastern references, plain and striped fabrics provide a base for intricate patterning reminiscent of wrought iron lace. Gabriella has chosen richly coloured silks which relate to the 'plunder' theme of the piece. She chose rich rust-coloured silk to contrast with the brown background and provide a base for the sumptuous embroidery.

Two different metallic threads have been used in 'Turkish Plunder'. The thicker thread used on the red squares is a fine couching yarn, with a deep gold thread through the needle. The brighter gold on the brown squares is a 30-weight machine-embroidery thread, stitched using red polyester in the bobbin.

So that the final work can proceed with as few distractions as possible, Gabriella always makes lots of samples to be sure that the fabrics and techniques will really work.

The Appliqué

The brown base fabric was stabilised with fusible non-woven interfacing, so an embroidery hoop would not be necessary for the embellishments. Gabriella first trimmed the square to 37 cm (14½ in) and overlocked the edges to prevent them fraying. Next, she drew a line on the interfacing side, 3.5 cm (1½ in) from all sides. She stitched along these lines to transfer the marking to the right side of the fabric, defining the centre square.

Rust-coloured silk was cut into 7 cm (2¾ in) squares and backed with Vliesofix fusible web. The squares were arranged on point within the marked square on the cushion front and fused in place. The edges of the squares were satin stitched in a matching colour. For the satin stitch, Gabriella used embroidery thread in the needle and reduced top tension, and black polyester thread at normal tension in the bobbin.

By experimenting with a loosened bobbin tension, many interesting effects are possible. Gabriella advises that it is important to make some sample pieces first to check the machine's tension. Always begin any freehand project with a few minutes of freehand 'scribble' on scrap fabric to 'loosen up', so the work can proceed smoothly.

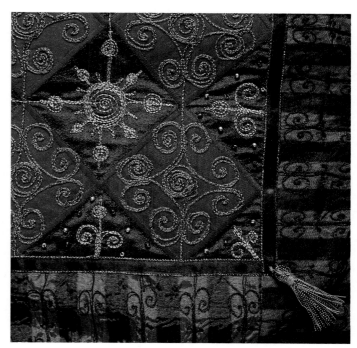

All the cabling is worked from the back of the piece, using a thread through the needle that contrasts with the fabric colour. The rust-coloured squares use brown thread while the brown squares use dark red thread.

The striped fabric of the border dictates the placement of the embroidery pattern – another spiralling design which complements the embroidery on the central medallion.

The Embroidery

Gabriella stitched her design freehand without guidelines, using the points of the square and diamonds as guidelines. However, she advises less experienced machine embroiderers to trace guidelines on the interfacing side of the work and to mark the diamonds with an X on the back to identify the various squares. She suggests practising on some scrap fabric before beginning a piece like this.

The complex pattern of coils and spirals is achieved using one of Gabriella's favourite techniques – cabling, which is stitched from the wrong side of the work. To accomplish this technique, Gabriella winds a heavier metallic cord onto the bobbin and uses a matching coloured machine embroidery thread through the needle. Using different colours together like this make her colours 'vibrate'. The unusual combinations make the adjacent colours excite each other, resulting in some surprising colour harmonies. If necessary, Gabriella advises, two needle threads can be used for added strength, threaded as if they are one. The bobbin tension can be loosened a little to allow for the thicker thread. The stitch length and width are set at zero, and the feed dogs are lowered or covered.

Because the thicker gold thread is wound on the bobbin, Gabriella turns the work wrong side up and stitches on the back.

Cabling is worked as a continuous line of stitching, so it is important to create a fluid line. For this reason, Gabriella urges some practice pieces with the design stitched on them in brown thread. It's also a good idea, she says, to wind several bobbins with the gold thread; working the practice squares will show how much stitching can be done with one bobbin of thicker thread, to avoid running out in the middle of a design.

The side panels were stitched separately in a freehand design of swirling loops on striped fabric, which was also backed with interfacing. Guidelines drawn on the right side of the fabric with a chalk pencil and ruler are helpful, as this part is worked from the right side. The needle is threaded with two strands of black embroidery cotton at slightly reduced tension; the bobbin is wound with black polyester thread at normal tension.

Completing the Cushion

The striped borders were seamed to the medallion centre square. The seams were pressed flat and covered with black satin ribbons stitched with gold. Tiny metallic beads were hand stitched to the outer triangles of the centre panel, and a flutter of small gold tassels added a final touch of opulence to a cushion that would be at home in a Sultan's palace!

The discipline which characterises the early stages is in evidence right to the end. 'The last hours of a project, the final finishing is the most difficult part. But I hate not completing anything, so I stick at it, and I have very few unfinished pieces.'

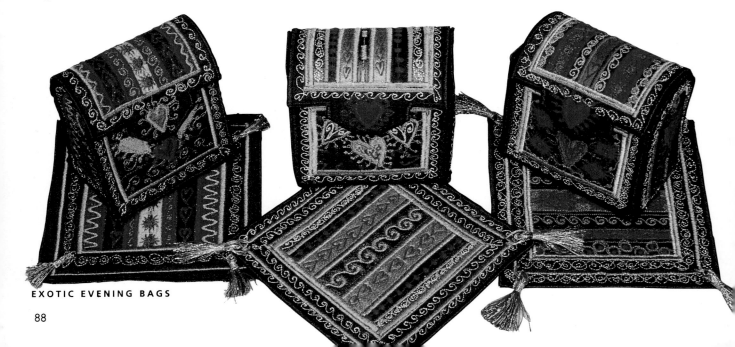

EXOTIC EVENING BAGS

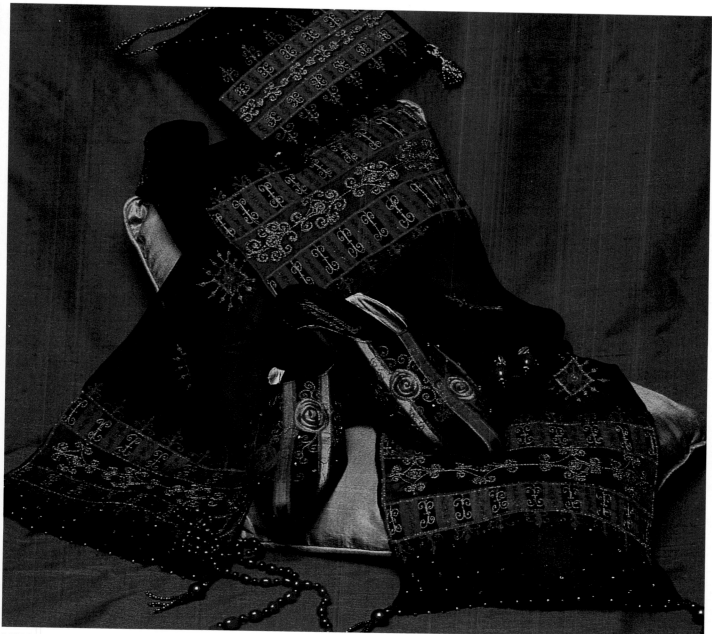

**EMBROIDERED CHIFFON SHAWL,
BAGS AND SHOES**

Watching Gabriella at work is a fascinating experience. Swirling back and forth with the grace of a ballroom dancer, her lines appear magically and grow like curling tendrils into intricate patterns. Clockwise, anticlockwise, it all looks so easy, and the rhythm of stitching doesn't vary, even when she chats to her students at the same time!

Gabriella has some good advice for all her students. 'Sew fast, and you'll break fewer needles. It's really worth the extra hours spent making sample pieces first. It may take some time, but the project will be quicker and more successful!' The wisdom of this is apparent. Gabriella says that after fifteen years of working in this field, she has very little of her work left, as it continues to sell. Teaching, travelling, and preparing articles for magazines keep her busy. The paradox is, that if the demand for her classes and sale items weren't so great, she'd have more time to devote to creating the artworks she loves, and exploring design and pattern still further.

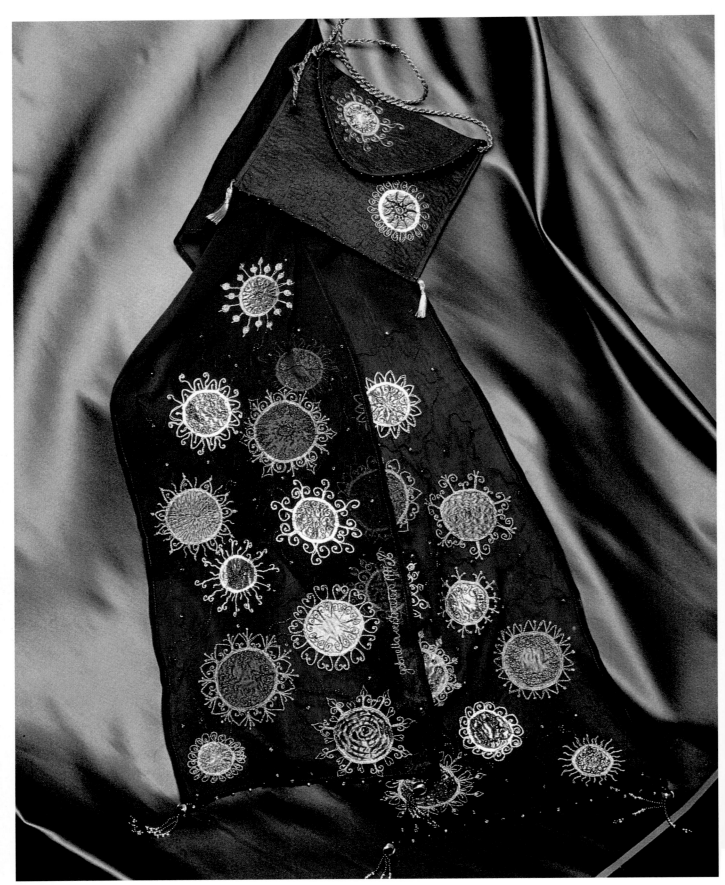

CHIFFON SHAWL AND SILK ENVELOPE PURSE

GLOSSARY OF METHODS AND MATERIALS

Appliqué
Additional fabric sewn onto the surface for decoration.

Appliqué mat
Teflon-coated sheet used to prevent the iron from sticking to fusible fabrics. Baking paper may be used instead.

Automatic pattern stitches
Repeating patterns formed by the machine, setting the width, length etc to create a continuous pattern. May be made completely automatically by pressing a single button or by using the stitch selection dials or cams (plastic inserts which change the width and length of the stitch as they rotate). Modern electronic machines also have a memory facility which allows you to select and programme your own patterns.

Backing fabric
Fabric on which the embroidery or appliqué is sewn.

Baking paper
Non-stick paper used to line baking trays (sheets) and cake pans. Ideal for use with embroidery as glues and fusible fabrics will not stick to it.

Bias
Line crossing the warp and weft threads at an angle of 45 degrees to the straight grain. Fabric cut on the bias grain has more stretch and drape than fabric cut on the straight grain, and a bias-cut edge will not unravel.

Blind hem foot
Sewing machine foot designed to be used with automatic blind hem stitch, which sews several straight stitches on the edge of the fabric, then does one zigzag stitch onto the folded hem, so that only very small spaced stitches will be visible on the outside of the garment. As the foot is designed with a metal guide to position it close to the fabric edge, it can also be used for very close, accurate edge stitching, when the needle position can be adjusted to the desired position.

Bobbin
The small circular metal or plastic spool on the underside of the machine, where thread is wound and used under tension. Stitches are formed by looping through the top thread with the bobbin thread as it passes over the bobbin case. Purchased pre-wound bobbins consisting of a fine thread wound into a small disc can be used if the bobbin case has a central spindle to support the bobbin as it unwinds. As it is possible to use several bobbins in an hour during intensive high-speed embroidery, such as thread painting, it's a good idea to wind several bobbins of the required colour before beginning the project.

Bobbin thread
Thread used in the bobbin. For normal utility sewing, the same thread will be used through the needle and the bobbin, which are both set at normal tension, so that an equal amount of thread will be visible on both sides of the fabric. For machine embroidery, many special effects are possible by using thicker or finer decorative threads in the bobbin and changing the bobbin tension. For inconspicuous results, the bobbin thread colour should be similar in tone to that used through the needle – dark bobbin thread for dark colours, white or cream for pastel colours etc. A fine thread, such as bobbinfil or superfine overlocking thread, may be used with good results in the bobbin, when using an embroidery thread through the needle and working on fabrics where the underside will not be visible. These fine threads allow considerably more thread to be wound onto a bobbin, meaning less frequent bobbin changes. In lace techniques where both top and bobbin thread will be visible, consideration should be given to the colour and appearance of the bobbin thread.

Bobbinfil
Fine thread made especially for use in the bobbin during machine embroidery.

Bobbinwork
Decorative embroidery technique where a thicker thread, cord or fine ribbon is used in the bobbin, which has reduced tension to allow the thicker thread to pass through the bobbin spring or bypass the spring altogether. As the decorative thread is attached to the underside of the work, bobbinwork is usually sewn with the wrong side of the fabric uppermost.

Bobbin tension
As the bobbin thread passes through the opening of the bobbin case, a small spring regulates how fast the thread will be drawn through. Bobbin tension is set by the manufacturer for use with normal utility sewing and standard threads. Check your machine instruction book for specific information relating to changing bobbin tension on your machine. If your machine has a removable bobbin case, it is possible to change the bobbin tension for special decorative effects by tightening or loosening the small screw on the side of the case. Extra bobbin cases can be purchased and kept at the required settings for bobbin work.

Cable stitching
Decorative embroidery technique where a thicker thread, yarn or fine ribbon is used in the bobbin, which has a loosened tension, and a standard thread is used through the needle, with normal or slightly tightened tension. The work is turned wrong side up during embroidery, so that the decorative thread will appear on the right side. Cable stitching can be done with automatic stitching, feed dogs raised, or with freehand embroidery.

Cornelli work

Decorative embroidery technique where a fine cord is used in the bobbin and stitched freehand to the fabric, which is placed wrong side up. The meandering curved movement typical of Cornelli work has closely curving lines which are evenly spaced and do not cross or connect.

Couching or braiding

Attaching a decorative yarn cord or braid to the surface of the fabric with stitching. Couching is a versatile technique which can be used to add a decorative line of thicker thread to the surface of the embroidery, to cover the edges of appliqué, or to create lace by couching yarns onto soluble fabric. Yarns can be couched inconspicuously with a matching thread so that the yarn is the decorative feature, or with a contrasting thread and a decorative stitch.

Couching or braiding foot

Machine foot suitable for attaching yarn, cord or braid to the surface of the fabric. It usually has one or more holes to thread the cord through and a channel or groove underneath to allow the foot to move easily over the couching. Various designs are available with different sized holes to take fine to heavy cords. Multi-groove couching feet have several grooves or holes to allow many cords to be attached simultaneously with utility or decorative stitching.

Denim needles

Machine needles with a longer, tapered point and a silicone coating made to penetrate easily through heavy fabric or multiple layers. Suitable for embroidery on heavy fabric or for use with heavily layered or ruched fabric.

Embroidery foot (also called satin stitch foot)

Machine foot made with a wide channel underneath to allow it to pass easily over raised areas of stitching, such as satin stitch. Also available in an open-toed version, which allows an uninterrupted view of the needle entering the fabric.

Embroidery needle

Machine needle specially made for fine or metallic machine embroidery threads. The special shaping and larger eye reduces the friction on the thread and helps to prevent shredding and splitting. Available in several sizes and in twin needles.

Fabric confetti

Sometimes called minced fabric. Fabric is cut into very small fragments using a rotary cutter or scissors. Fabric confetti can be used to add texture or colour to embroidery. The small pieces can be positioned and sewn individually or sprinkled over the glue side of fusible fabric and ironed under baking paper until the tiny pieces adhere. Stitching over the surface will then attach the scraps firmly.

Fabric marking pen

Used for marking fabric before embroidery or cutting. Marks may be removed after use by sponging with water (washable marking pen) or by exposing to light (light fading pen.) Use with care and always test on scrap fabric before use. Do not iron over the marks as this can set them permanently.

Feed dogs or feed teeth

Serrated metal teeth projecting through the slot in the needle plate which draw the fabric forwards or backwards under the needle. For freehand machine embroidery, the feed dogs are lowered or covered with a metal or plastic plate, and the fabric is moved manually.

Freehand embroidery

Machine embroidery technique in which the feed dogs are lowered or covered so that the fabric can be moved freely by hand under the needle. This is usually used with the machine running fast and the fabric moving slowly, to avoid the risk of broken needles. To avoid distortion of the fabric, (unless this is a desired effect), the fabric should be firm, supported by a stabiliser, or stretched in an embroidery hoop.

Freehand embroidery foot

Machine foot suitable for freehand embroidery, i.e. sewing with the feed dogs disengaged. Most freehand embroidery feet have an internal or external spring mechanism which moves up and down with the needle, so the foot holds the fabric down while the needle pierces it, thus making a stitch and then moves up when the needle is out of the fabric, allowing the fabric to be moved in any direction. Some models have a cut-out front for improved access and visibility. If this model is not available for your machine you may be able to modify the existing foot.

Hoop

Two circles of wood, cane, metal or plastic that fit closely together to allow fabric to be tightly stretched for embroidery. Slim wooden hoops are the best quality and the best choice for holding the fabric as firmly as possible. A screw or spring on the outer hoop allows for adjustment for various thicknesses of fabric. Cover the inner hoop with a thin wrapping of bias tape to ensure a firm grip especially on thin or slippery fabrics. Spring-loaded hoops have an outer grooved ring of plastic, and an inner partially open metal frame with two handles which can be squeezed together to allow the metal frame to fit into the groove on the plastic ring, holding the fabric stretched. This hoop will not hold the fabric as firmly as a wooden hoop, but it is ideal for techniques where the hoop needs to be repositioned often, as when making lace on soluble fabric. The hoop can then be moved to a new area without removing the work from the machine.

Knee lift

Detachable knee-operated lever available on some models of Bernina machines which simultaneously raises the presser foot and lowers the feed dogs, leaving both hands free to move the work.

Machine embroidery threads

Fine glossy and metallic threads used for machine embroidery. Finer than standard thread and not strong enough for seams, they are available in a wide range of colours, plain, variegated and metallic. For best results, use them with a machine embroidery needle and loosened top tension.

Machine-made cords

Technique of making decorative cords on the machine by stitching over several strands of yarn, cord, ribbon or fabric strips. To maintain tension on the cords so they will feed easily and not slip into the hole in the needle plate, hold the cords firmly in front and behind the foot. Stitch patterns can be utility or decorative.

Machine oil

A fine quality oil used to lubricate some moving parts of the machine,

such as the hook race. Be sure to buy the brand recommended by the machine manufacturer, as some cheaper brands can become unpleasantly thick and sticky with age, and may damage the machine.

Meandering

Freehand embroidery movement similar to that used in Cornelli work and stipple quilting. Can be used with a single, double or triple needle, with different colours to give a shadowed effect.

Mossing

Freehand embroidery technique where the bobbin is filled with a thicker thread such as pearl cotton or rayon and the needle is threaded with a toning or contrasting thread in polyester or cotton. The bobbin tension is slightly loosened and the top tension slightly tightened, and the embroidery is worked wrong side up. By running the machine fairly fast and moving the fabric slowly, the bobbin thread builds up thickly giving a raised, bobbled texture similar to moss.

Muslin

Fine, loosely woven cotton fabric similar to the gauze used for bandages. Useful for machine embroidery as the loose weave means that the threads can be drawn together to create an effect similar to hand-drawn threadwork. Muslin dyes well and can be incorporated into collage work for texture. However the fibres are not strong, so it is not generally successful in areas that will be subjected to heavy wear or frequent laundering.

Needle weaving

Creating a woven type of fabric by stitching back and forth over a soluble fabric or open space. Similar to darning, but used decoratively.

Overlock threads

A fine thread used in overlock machines. The best quality overlock threads are also suitable to use in the bobbin when fine machine embroidery threads are used in the needle. Cheap, fuzzy overlock threads do not perform well and break frequently. Thicker decorative threads used in the looper of the overlocker can sometimes be used effectively in the bobbin or for couching.

Paint marker

Marking pen filled with white oil-based paint. Available in fine, medium and bold point sizes. Dries quickly to a clearly visible white line, which is useful for drawing on soluble fabric where a water-based pen is not suitable.

Paper-backed fusible web

Fine, thread-like web of glue attached to non-stick paper. Use by placing the glue side down on the wrong side of the fabric and ironing over the paper until the glue melts, thus creating fabric which has an adhesive backing. Useful for appliqué as a shape can be traced on the paper backing, cut out and the paper removed so that the shape can be fused in position on a backing fabric. Remember to trace the shape in reverse so it will be the right way round when appliquéd. Small scraps of fusible web are also useful for holding pieces of fabric in position when pins are unsuitable.

Perspex insert

Clear plastic tray made to fit around the free arm of the machine when it is being used in a sewing cabinet fitted with an automatic lift.

The perspex extends the flat sewing area around the foot at the same level as the top of the cabinet and the clear plastic allows easy vision of whatever is underneath, so that the bobbin can be changed without removing the tray. A boon for sewers.

Pressing cloth

A cotton cloth used over delicate fabric or embroidery to protect work from excessive heat or marking. A dampened pressing cloth generates more steam, which can help to set a crease or remove wrinkles.

Reverse appliqué

Technique of layering several fabrics and cutting away successive layers from the top down to reveal the fabrics underneath.

Rotary cutter

Very sharp, circular cutting blade attached to a handle and used with a rolling motion to cut multiple layers of fabric. A safety cover slides over the blade when not in use. Rotary cutters must be used with a special plastic mat which is not damaged by cutting. Available in several sizes, and with additional blades which cut in a wavy or zigzag line, creating a decorative edge and preventing fabric from fraying. Indispensable for patchworkers.

Rouleaux

Narrow tubes of fabric made by cutting a strip of fabric on the bias, sewing it into a tube with a narrow seam and turning it right side out. Because the fabric is cut on the bias, the tube is slightly stretchy when finished. A gadget called a rouleau or loop turner makes it easy to turn narrow tubes right side out. It is a long thin piece of metal with a closed hook a little like a safety pin at one end and a ring handle at the other end.

Safety glasses

Clear plastic glasses used to prevent eye injury when using fast moving machinery such as a lathe or a sewing machine. Recommended for use when broken needles are a possibility. Safety glasses are now available in many comfortable and attractive designs from hardware stores and optical dispensers. Prescription glasses with large lenses also offer some degree of eye protection.

Satay stick

A fine bamboo stick with a pointed end. Useful for manipulating or holding fabric as you sew, thus preventing stitched fingers.

Satin stitch

Zigzag stitches sewn very close together, so that stitches form a flat ribbon, which can be tapered by widening or narrowing the stitch width control while sewing. Satin stitch can be given a raised or padded appearance by sewing two or three rows one over another, each row a little wider than the previous one, or over fine cord. Stitch length for satin stitch is usually around 0.5, though this will vary a little depending on the thickness and number of threads used. For best results, the base fabric should be stabilised with a firm or tear-away backing or stretched in a hoop. To ensure that the bobbin thread does not show and the top thread does not break, the top tension should be loosened a few degrees for polyester thread and a little more when using finer threads such as rayon or metallic embroidery threads. Test sew first.

Satin stitch foot
See Embroidery foot.

Serpentine stitch
A utility stitch used for sewing elastic, which is often used decoratively. It is made as a running stitch that curves from side to side in a regular wavy pattern. On some machines it is called a three-step zigzag as the pattern is more angular than wavy.

Spool holder
Stand positioned behind the machine for holding larger spools of machine-embroidery thread. A central spindle mounted in a firm base holds the spool and the tall metal loop stand through which the thread passes before being threaded as normal through the guides on the machine. As the thread is drawn up from the spool which does not rotate, there is less chance of silky thread collapsing off the spool and causing tangles and thread breakages. Available as a single stand, and also in larger, more complex models with spindles for several spools.

Shibori
Technique of creating patterns in dyed fabric, where the fabric is stitched or tied to prevent the dye from penetrating.

Shuttle
The movable, semicircular part of the machine that partly encloses the bobbin. It is designed with a pointed portion called the hook which passes through the loop of thread made by the needle, thus forming a stitch.

Silk paper
Lustrous, firm, papery, felt-like fabric made by layering silk fibres at right angles and pasting with a liquid textile medium, which glues the fibres together. Can be used as a base for embroidery or moulded while wet to create three-dimensional forms.

Stabiliser
Material used behind embroidery fabric when sewing to prevent puckering, tearing or stretching. Some stabilisers are like a papery, non-woven interfacing which add a firm backing to the fabric while being embroidered and are removed when the embroidery is completed. They are available in many different forms and degrees of stiffness: permanent iron-on, removable iron-on, tear-away and wash-away. Some of the stabiliser will be trapped permanently behind the stitching, adding firmness to the embroidered area. Other types of stabilisers are soft fabrics, such as cold-water soluble stabilisers, which are used under fine embroidery such as net, silk or voile for additional support when they are stretched in a hoop. As cold-water soluble fabrics can be removed completely by rinsing, the embroidered area is stiffened only by the intense stitching.

Stipple quilting
Freehand quilting where the stitching moves in a curved meandering line which does not cross or connect. Similar to the movement used in Cornelli work.

Suffolk puff
Circle of fabric, gathered around the circumference, with the gathers pulled up tightly into the centre forming a flat rosette. Often used by patchworkers to form a quilt top composed of many small circles. Used in machine embroidery to create raised areas of texture.

Tension dial
Device for regulating the pull of the thread through the needle. The thread passes from the spool between two metal or plastic discs which can be tightened or loosened to control the passage of the thread. Normal top tension is set to allow a balanced stitch when using standard polyester or cotton dressmaking thread in needle and bobbin. However, as rayon and metallic machine embroidery threads are finer and less strong than standard thread, the top tension should be loosened in varying degrees, so that the thread is not pulled so tightly, causing it to break. As a general rule, the finer the top thread, and the greater the stitch width, the more the top tension needs to be loosened for best results. For some special effects, such as whipstitch, where a fine thread is used at a very loose tension in the bobbin, and a standard thread is used in the needle, the top tension should be tightened several degrees. Always return tensions to normal before using the machine for utility sewing.

Thread painting
This technique is a way of filling in areas with close freehand straight or zigzag stitching. It is advisable to work on fabric that is stretched tightly in a wooden hoop to avoid distortion or puckering caused by the intensive stitching.

Thread snips
Small, spring loaded scissors used by squeezing the outside of the plastic-covered or metal blades. An indispensable tool for machine embroidery.

Twin needle, triple needle
Double or triple needle attached to a single shank. Used for pintucking effects on fabric where the two or three top threads and a single bobbin thread pull the fabric up into a small ridge. It is also effective when used with some pattern and utility stitches. It is very important not to exceed the recommended stitch width when using a twin or triple needle, or the needle will swing too wide and hit the foot or the needle plate. Some machines have a twin needle governing button which automatically controls the stitch width when a pattern is selected. Never turn the fabric while the needle is down, as this will cause it to twist and break. Twin needles are available in different spaced widths and sizes, in styles suitable for standard or embroidery threads, and in combinations of a wing needle and standard or embroidery needle. Although twin needles are considerably more expensive than regular needles, they become blunt just as quickly, and require changing just as often.

Utility stitch
Basic automatic stitches used for garment construction, seams, hems on stretch fabric and edge finishing. Many of these can also be used decoratively.

Vanishing muslin
Partially sheer, open-weave stiffened cotton fabric used as a temporary backing for embroidery. It may be removed after the embroidery is completed by ironing on the reverse side with a warm to hot iron, which causes the specially treated muslin to scorch and disintegrate to a fine pale brown powder, which is then brushed away.

Walking foot

Machine foot with feed teeth underneath which work together with the feed teeth on the machine to draw fabric through evenly while stitching. Useful for sewing slippery or difficult fabrics such as plastic, leather and rubber-backed curtain fabrics, and is ideal for machine quilting several layers of fabric and batting. It is also good for use with striped or patterned fabric which require precise matching, or with piled fabrics like velvet. If these are pinned together firmly, the walking foot will feed them evenly so that they do not slip out of alignment. Some machines have a built-in walking foot which should be raised or removed when using an embroidery hoop. Indispensable for machine quilters.

Water-soluble fabric

Plastic-like fabric, available in varieties that are soluble in cold, hot or boiling water, and is always used stretched in a hoop. Very versatile, it can be used as a stabiliser behind embroidery, as a base fabric for lace making, as a top layer when sewing very fuzzy or hairy fabric which may tangle around the foot, as a base fabric to support free shapes when doing cutwork and as a support fabric to enclose threads or fabric shapes when creating fabric. It is indispensable for lace making on the machine. It is now possible to buy hot-water soluble hospital laundry bags which are stronger and cheaper than cold-water soluble fabric and are dissolved in very hot soapy water. Always make a test sample when using any kind of soluble fabric to determine the effect of the hot or cold water on the threads and fabrics you will be using. When making lace by couching yarns on soluble fabric, it may be necessary to pre-shrink the yarns before use, to avoid excessive shrinkage during the dissolving process.

Whipstitch

Freehand embroidery technique using a very loose tension in the bobbin and a tightened top tension. The machine is run very fast, while the hands move the work very slowly, so the bobbin thread is drawn to the surface to wrap around the needle thread, giving it a raised corded appearance.

Wing needle

Machine needle with a wide blade on both sides which separates threads to make a hole in fabric and is used for decorative effects like hemstitching. It is available in a twin needle combination. As the blade increases the width of the needle, it is important not to exceed the recommended stitch width when sewing zigzag or pattern stitches with a wing needle.

Zigzag foot

Machine foot with a flat base and a rectangular slot for the needle. Suitable for straight or zigzag stitching.

THE ARTISTS

Cheryl Bridgart
PO Box 589
Prospect East
South Australia 5082
Tel/Fax: 08 8262 1245

Trudy Billingsley
119 Collins Rd
St. Ives
New South Wales 2075
Tel: 02 9449 4141
Fax: 02 9440 0681

Kristen Dibbs
33 Wingate Ave
Eastwood
New South Wales 2122
Tel: 02 9874 7752
Fax: 02 9874 7204

Alvena Hall
8 Mara Place
Westlakes
South Australia 5021
Tel/Fax: 08 8347 0424

Helen Lancaster
12 Riverview Rd
Padstow Heights
New South Wales 2211
Tel: 02 9771 4501

Annemieke Mein
PO Box 1444
Sale
Victoria 3850

Celia Player
101 McCarrs Creek Rd
Church Point
New South Wales 2105
Tel: 02 9997 3973
Fax: 02 9997 3185

Judith Pinnell
16 Watkins Rd
Dalkeith
Western Australia 6009
Tel: 09 9386 7868

Ken Smith
email; topsilk@powerup.com.au
web:http://www.powerup.com.au/~topsilk
Tel/Fax: 07 3367 3119
Mobile 0412 577 896

Wendy Wright
18 Beatty St
Coalfalls, Ipswich
Queensland 4305
Tel/Fax: 07 3281 3664

Gabriella Verstraeten
c/-242 Tooronga Rd
Tooronga
Victoria 3146
Tel: 03 9822 3137

EDITORIAL
Managing Editor: Judy Poulos
Editorial Assistant: Ella Martin
Editorial Coordinator: Margaret Kelly
Editorial and Production Assistant:
Heather Straton

PHOTOGRAPHY
Andre Martin

STYLING
Kathy Tripp

PRODUCTION AND DESIGN
Production Director: Anna Maguire
Production Coordinator: Meredith Johnston
Design Manager: Drew Buckmaster
Production Editor: Sheridan Packer
Cover Design: Lulu Dougherty

Published by J.B. Fairfax Press Pty Limited
80-82 McLachlan Ave
Rushcutters Bay, Australia 2011
A.C.N. 003 738 430
Web address: http://www.jbfp.com.au

Formatted by J.B. Fairfax Press Pty Limited

Printed by Toppan Printing Co. Singapore
© J.B. Fairfax Press Pty Limited 1998
This book is copyright. No part may be reproduced by any process without the written permission of the publisher. Enquiries should be made in writing to the publisher.

JBFP 504

MACHINE EMBROIDERY
Inspirations from Australian Artists
ISBN 1 86343 330 9

DISTRIBUTION & SALES
Australia: J.B. Fairfax Press Pty Limited
 Ph: (02) 9361 6366
 Fax: (02) 9360 6262
USA: Quilters' Resource Inc
 2211 Nth Elston Ave
 Chicago 60614
 Ph: (773) 278 5695
 Fax: (312) 278 1348